THEN & NOW

BELMONT

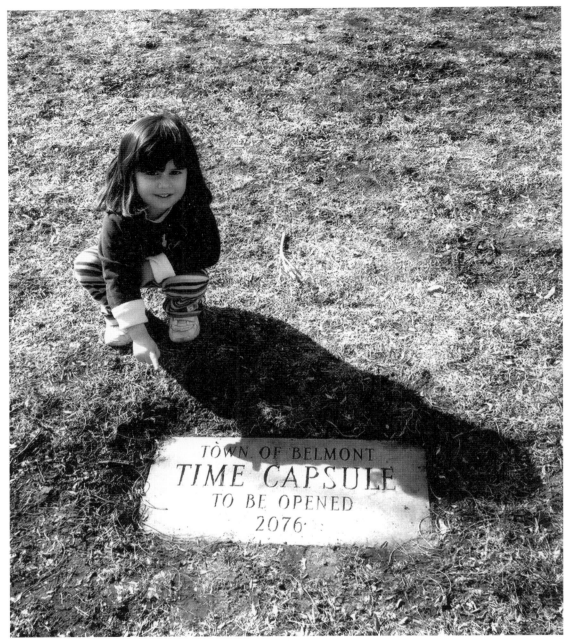

In the middle of the delta in Belmont Center, buried nine feet underground, is a concrete vault measuring 22 by 24 by 68 inches. Sealed safely inside are more than 500 items, including letters, newspapers, and artifacts of current and past significance, donated by various groups and individuals around town. The vault was sealed and then lowered into place by a large crane on October 16, 1977, marking the last of the events organized between 1975 and 1977 by the Belmont Bicentennial Committee to celebrate America's 200th year. The marker recently caught the attention of a youngster who may still be present when the vault is opened in 2076.

Then & Now
BELMONT

Belmont Historical Society

ARCADIA

First published 2004

Published by Arcadia Publishing,
Charleston SC, Chicago IL, Portsmouth NH, San Francisco CA

Printed in Great Britain

Library of Congress Catalog Card Number: 2004106063

For all general information, contact Arcadia Publishing:
Telephone 843-853-2070
Fax 843-853-0044
E-mail sales@arcadiapublishing.com
For customer service and orders:
Toll-free 1-888-313-2665

Visit us on the Internet at www.arcadiapublishing.com

CONTENTS

ACKNOWLEDGMENTS

The Belmont Historical Society is grateful to coauthors Helen Blakelock and Victoria Haase for lending their time and talents to this project and to Bob Blakelock and Jefferson Haase for their contributions. Their collective efforts have enhanced the pages of this book and have added to the permanent record of Belmont's unique history. Thanks also go to those individuals who were so generous with photographs from their family albums, complementing the selection from the society's archives, and to those who made the task of collecting and researching so memorable. Your enthusiasm and support have made our job enjoyable and rewarding.

This book is dedicated to Richard B. Betts, Belmont town historian, for his lifelong devotion to the collection of memorabilia, artifacts, and information pertinent to Belmont and for sharing it with the community. His efforts have greatly enriched our appreciation for the town in which we live.

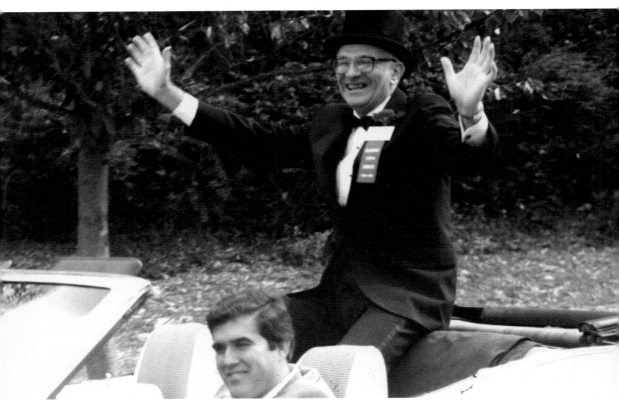

Richard B. Betts is pictured here as honorary parade marshal.

INTRODUCTION

Although Belmont's history has been told through the years in many ways, this volume combines the past with the present in an interesting then-and-now format. The Belmont Historical Society holds an extensive collection of historic photographs, which, when viewed together with images of contemporary scenes, create this time line of everyday life as a work in progress. Throughout these pages, you will see the visual evidence of both dramatic change and long-term stability. Our rural farmland and our new neighborhoods have brought together lifetime residents and first-time homeowners, both of whom will enjoy this book.

History, very often a term confined to isolated vignettes of long ago, is viewed here in the context of everyday events. The photographs of the Waverly Post Office on the front and back covers of the book introduce the style in which this visual essay will be told. The captions that accompany each pair of old and new images will supply information about the subject or location, adding both depth and dimension to the visual. For example, did you know that the first Waverly Post Office occupied an 8- by 10-foot space in Russell's General Store on the ground floor of the first Waverley Hall on Church Street? Did you know that the early Waverley Citizens Association petitioned the post office to put the second "e" in the name to no avail? Each chapter is filled with images of past and present, offering a mix of people, places, organizations, and events that have helped to shape this town.

Tradition, growth, and change have been part of Belmont's history from its founding in the 1600s through its struggle for incorporation in the 1800s and remain evident today. Early settlers, who were mostly farmers, first shared the land with the Pequosette Indian tribe. As the population of the area grew, so did the demand for fresh produce, which was grown in abundance in the rich soil of this rural Boston suburb. Wagons laden with some of the finest fruits and vegetables in the region made the short trip to the markets in Boston. The scenic and beautiful surroundings soon caught the attention of city dwellers who were anxious to escape the noise and the heat by spending the summer season here building large estates to reflect their wealth.

Out of this group of original farmers, early businessmen, and prominent citizens came the leadership necessary to fight for independence, and in 1859, despite fierce opposition from Watertown, Waltham, and West Cambridge, Belmont won its five-year battle for incorporation. Although geographically a mere 4.6 square miles, Belmont was among the richest towns in the state. The extension of the railroad and addition of trolley service made little "Belle" more accessible and contributed to the dramatic rise in population. As agriculture gave way to technology, new neighborhoods quickly replaced large tracks of farmland and Belmont soon earned its reputation as "the Town of Homes." Today, change has met tradition head-on as Belmont struggles to keep its small-town atmosphere while finding its place in the new millennium.

Through thematically organized photographs, this book portrays the "Changing Times" and "Lasting Legacies" that are part of this community's development. Although some local landmarks like Corbett's Drug Store have closed, succumbing to competition from national retail chains, much about Belmont remains. Signature buildings like the Belmont Town Hall and the former Underwood Library have been creatively remodeled for reuse to house town and school department employees. The Pleasant Street

Historic District continues to protect properties representing distinct architectural styles of a bygone era. As plans for proposed future development progress, what value will be placed on preservation of property and open space? Decisions are now being made regarding the two historic fire department buildings and the Belmont Uplands that will test the tension existing between tradition and modernization.

Familiar "Faces and Places" are also featured throughout these pages, including members of the Belmont Dramatic Club who celebrate their centennial year, retiring Fire Chief William Osterhaus, and a group of talented high-school students known as the Madrigal Singers. "Common Ground" remembers the places where we come together. Whether we are feeding the ducks at the Mill Pond, planting a garden plot at Rock Meadow, or listening to a concert at Payson Park Park, Belmont residents value community. Today, the town is home to a diverse mix of people whose lifestyles and contributions provide the framework on which we continue to build. The unique features of Belmont and its inhabitants are captured in "Different Strokes," where the ordinary becomes the extraordinary with the passage of time and noteworthy events of the day are considered "history in the making."

Over the past 100 years, great strides have been made in the evolution of Belmont from its rural beginnings, causing it to emerge as a prominent suburban locality.

Belmont offers an interesting look at the parks, schools, clubs, events, and monuments that fill our lives and attempts to provide the reader with a greater understanding of how to view the past with the future in sight.

Roger Wellington, a ninth-generation descendant of Belmont's original settler by the same name, poses along the banks of Wellington Brook, showing off his pet "crocodile" for the camera. The brook originates in the Waverley section of town and drains 619 acres along its route as it passes through the most thickly settled portions of Belmont. It eventually flows out to Boston Harbor via the Mystic River.

Chapter 1

COMMON
GROUND

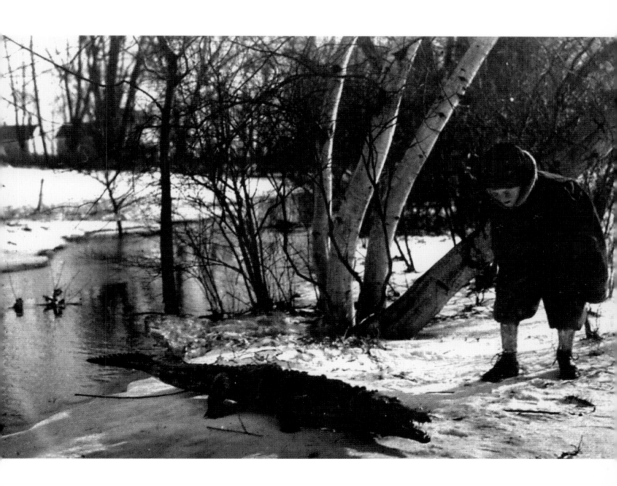

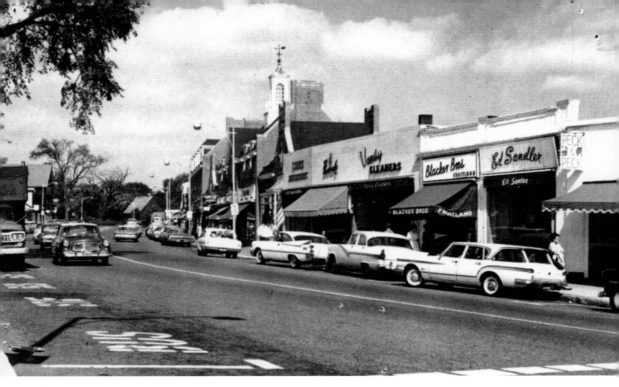

Belmont Center occupies land once part of the Wellington family farm, which ran from Pleasant to Brighton Street. In the mid-1920s, the area was developed into house lots and family-owned stores. However, today's high retail rents discourage small businesses and promote a continuing shift to national chain stores. Sponsored by the Belmont Center Business Association, Town Day has become a popular annual event during which Leonard Street becomes a pedestrian-only area. Included in the schedule of activities are a pancake breakfast, a road race, a dunk tank, and pony rides. Belmont Center merchants attract potential customers with sidewalk sales, while a variety of organizations and vendors line Leonard Street with booths and displays. Appetites are satisfied with foods of all kinds.

In 1968, the town purchased farmland along Mill Street owned by McLean Hospital. Staff and patients had been well provisioned by the two piggeries, a large dairy herd, which produced 125 gallons of milk daily, and plenty of fresh produce until the 1940s. Under the management of the Belmont Conservation Commission, the 70-acre site now attracts a large variety of birds and wildlife that share the surrounding hills, extensive meadows, wooded landscape, and numerous springs. The commission, which sets and enforces restrictions, began in 1967 with only one-half acre of protected open land. A long-range "green wedge" land use plan was prepared at that time and has been slowly implemented. Belmont's preservation of open space has continued to grow; today, it includes some 200 acres.

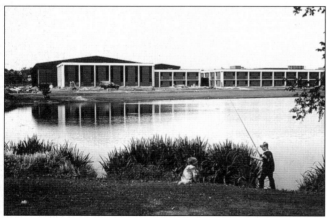

The town purchased 38 acres of Concord Avenue land in 1927, including an abandoned clay pit used by brickmaking businesses operating there from 1874 to 1926. Wellington Brook was diverted to discharge into the pit, creating a pond. Since then, the area has attracted Belmont residents who enjoy a variety of recreational activities. They share the environment with snapping turtles, Canada geese, and ducks. Two months after a fire destroyed the auditorium and classrooms of the Orchard Street High School in 1967, residents voted to construct a new high school on the east side of the pond. It was ready for occupancy in 1971 at a cost of $9 million. Fishing provides an interesting contrast to its construction just beyond the far bank.

Formerly the home of Ruth Hornblower Churchill, the Georgian Revival house at 10 Juniper Road was originally laid out with carefully planned gardens featuring local species. The surrounding property was later developed to include meadows, ponds, and woodlands to attract a variety of wildlife. Following Ruth Churchill's death in 1970, the estate became a center for environmental education and, since 1994, has been staffed by the Massachusetts Audubon Society, the largest conservation organization in New England. Today, the Habitat Education Center and Wildlife Sanctuary is opened to visitors every day year-round. The painting by local artist Scott White captures the beauty and tranquility of the gardens, which are set in an 86-acre wildlife sanctuary of varied habitats. (Above, courtesy of Habitat.)

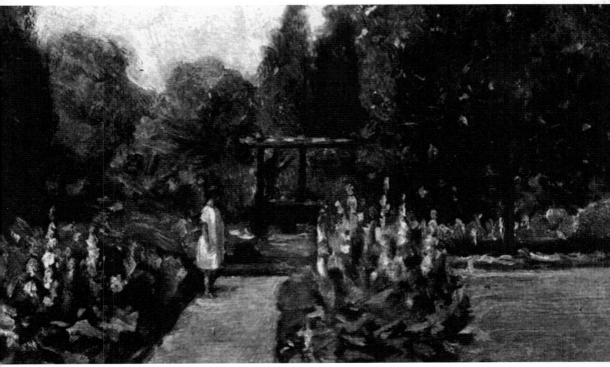

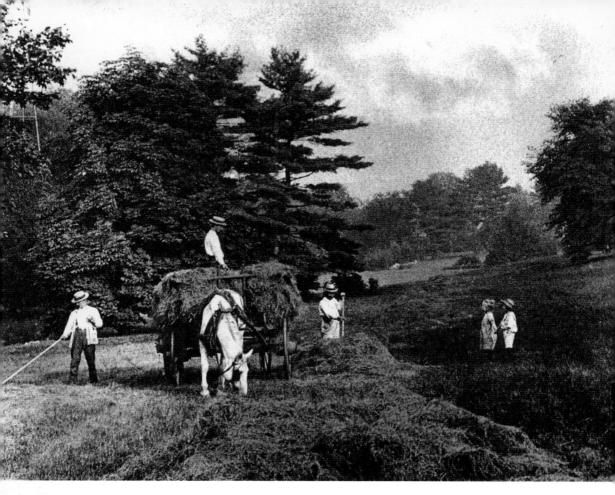

The early-20th-century photograph recalls Belmont's agricultural past and the country estates on which gentleman farmers landscaped their grounds with a variety of common and unusual species of trees, shrubs, and flowers. The seasonal task of haying took place on a 14-acre parcel of land owned by Samuel Mead off School Street. The property was later purchased by Henry Underwood, who then gave it to the town for a playground. He strongly believed that a place for children to play was badly needed in this part of town. New equipment donated in 1999 adds to the playground's popularity during recess at the Roger Wellington Elementary School across the street.

The Benton Branch Library was originally built as a chapel for the Belmont School for Boys. Benjamin F. Harding opened the school in 1889, when he purchased Bellmont Mansion and 15 acres of land from the estate. The chapel, constructed and consecrated in 1892, was used as a place of worship until 1899, when the school was closed. Col. Everett C. Benton purchased the property in 1903 and made the stone chapel available for religious meetings and other community functions. The Payson Park Congregational Church and the Belmont Methodist Church met and organized there. After Benton's death, the family offered the chapel to the town, and in 1930, residents voted to

accept the building and land in memory of Everett C. Benton. It has served the town as a library ever since.

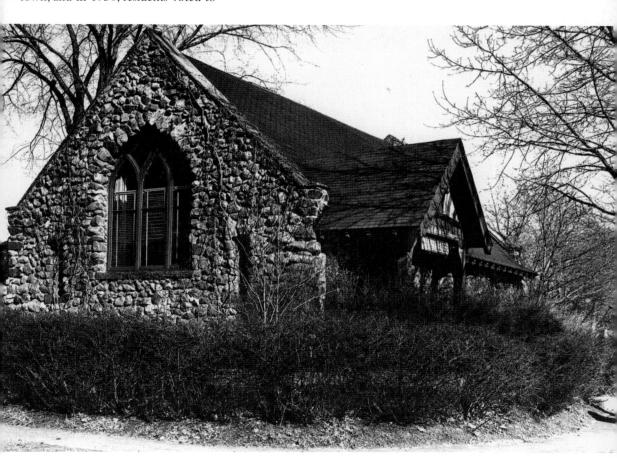

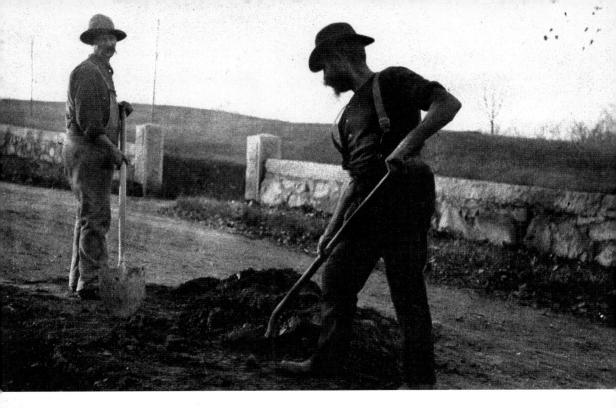

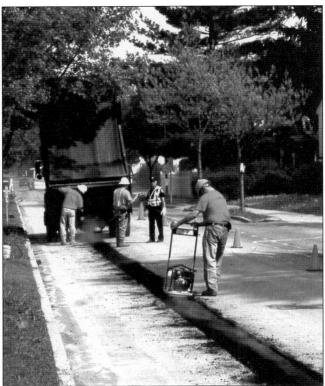

The Belmont Annual Town Report of 1900 records the selectmen as stating, "Aside from the schools, it is an admitted fact that nothing contributes so much to the comfort and progress of a community as good roads." When the town was incorporated in 1859, the selectmen acted as surveyors of highways and were responsible for the upkeep and construction of the town's 22 miles of local roads with a budget of $1,200 a year. The streets remained gravel until 1907, when the first tar surface was applied on Pleasant Street. Road crews, past and present, perform the necessary maintenance on sections along upper and lower Concord Avenue. Today, the highway department is responsible for 78 miles of pavement requiring an operating budget of $797,338.

The Payson Park School bore the family name of prominent citizen Samuel R. Payson. Built in 1914 on the corner of Payson Road and Elm Street, the schoolhouse was enlarged by a classroom addition in 1920 and a multipurpose room in 1960. The neighborhood structure was destroyed by fire in 1971 and razed in 1976, when a town-wide referendum overturned the town meeting vote to rebuild. Today, the area known as Payson Park Park is the venue for the popular Payson Park Music Festival. The 12-week summer concert series runs from June to September and features a variety of musical styles including jazz, big band, Caribbean, and blues. The festival is supported by local residents and area businesses in cooperation with the Belmont Recreation Department.

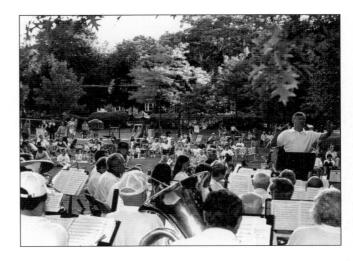

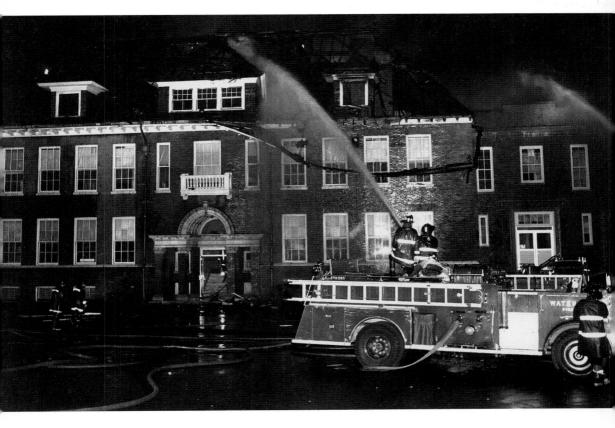

Grading and landscaping along Concord Avenue were part of a Works Progress Administration (WPA) project in 1933. The area has been much improved, and when the high school was built, the northwest side of the pond was replanted. The Ruth Ippen Tree Walk honors the efforts made by this local resident and active Belmont Garden Club member to enhance open space including the south side of Clay Pit Pond bordering Concord Avenue and Underwood Street. The Shade Tree Committee, charged with the planting, maintenance, and design of public land, has focused on the development of an educational and aesthetic arboretum here. A total of 27 varieties of trees including magnolia, katsura, and gingko have been labeled and listed on maps available at the town clerk's office, allowing residents a self-guided tour. (Below, courtesy of the Mandanian-Reppucci family.)

Wellington Brook is an important part of Belmont's storm drainage system, receiving about two thirds of the water in town. The watershed originates at Lexington and Belmont Streets in a 10-inch diameter pipe and runs through countless backyards and neighborhoods as it manages large volumes of rainwater throughout the greater part of Waverley, Belmont Center, and Cushing Square. In heavy storms, the brook can quickly rise four to five feet. Organized under a WPA work project, this 60-inch-diameter concrete pipe was laid underground through the new town yard off C Street. The job employed 52 men, both skilled and unskilled, who supplied an estimated 284 man hours.

To properly drain this section alone required a sewer area more than two miles in length.

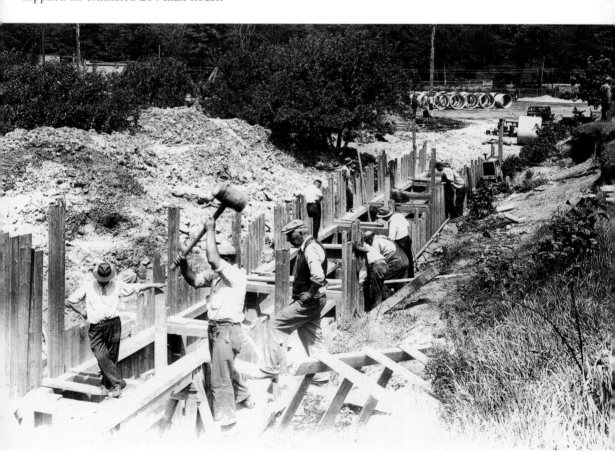

Victory gardens were popular in Belmont during the war years, when parcels of land located around town produced fresh vegetables in short supply. Today, the practice continues on town-owned land off Mill Street under the coordinated efforts of a group of volunteers headed by Bruce Westgate. Plots are available for a fee of $13 a year, which is collected to cover the cost of water and an annual bulletin. Currently, 100 gardens yielding a wide variety of vegetables and flowers are tended by area residents, 80 percent of whom are from Belmont. New lots varying in size by location are assigned each spring, and crops are sown in the hope that plantings will avoid the detection of skunks, rabbits, woodchucks, and raccoons that share the open space.

In 1911, H. O. Underwood offered to construct a playground, swimming pool, and bathhouse on a parcel of his land on Concord Avenue. Wellington Brook flowed through the lot, and several natural springs bubbled forth. Underwood believed the site would make a good "swimming hole." The original design by his brother Loring included a cobblestone sand-covered bottom, creating a beachlike effect. Underground springs supplied 70,000 gallons of fresh water daily. For a nickel, towels, toilet articles, a shower, and swimming instructions were provided. Opening in 1912 as the first outdoor swimming pool in the country, the pool remains a popular summer destination. Passes for the June–September season are available from the Belmont Recreation Department at a cost of $45 per child or $100 per family.

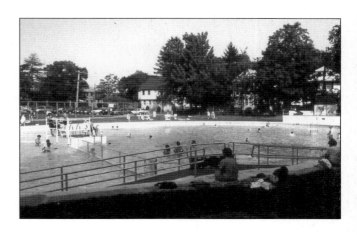

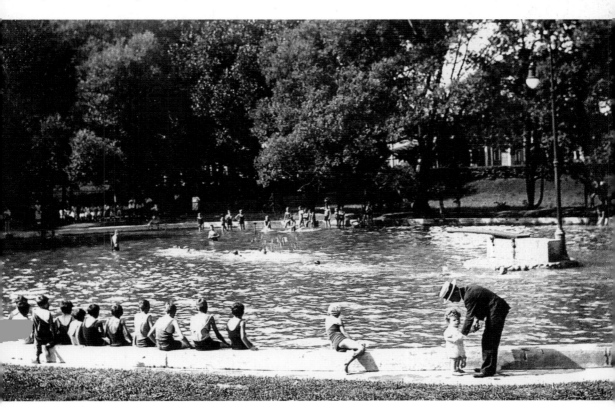

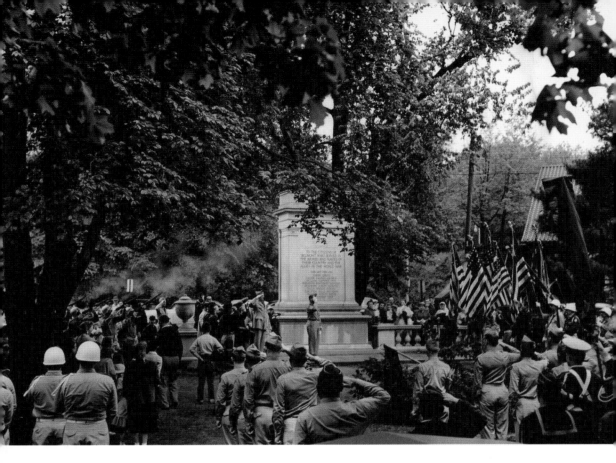

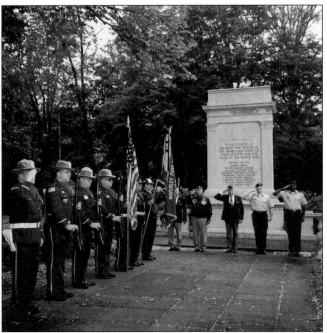

The delta of land at the junction of Common Street and Concord Avenue is town parkland. Originally, when the railroad crossing was at grade, Common Street ran behind the delta and the parkland extended uninterrupted toward the Unitarian church. In 1907, when the streets were reworked for the underpass to Belmont Center, Common Street was relocated through the park, creating the delta. Today, the delta is the setting for the World War I monument, made of Bethel white granite. A "simple, dignified memorial possessing the quality of permanence but with the quality of cheerfulness also—a memorial that breathes the spirit which has inspired its erection and the sacrifices which it commemorates." It was dedicated on November 11, 1923.

A popular wintertime activity for Belmont youth is ice-skating. To avoid the potential danger of breaking through thin ice caused by underground springs feeding Fresh and Spy Ponds, a shallow rink along Concord Avenue was created by damming Wellington Brook. Although located on private property, this ice was enjoyed by girls at one end and boys with sticks and pucks at the other. In the 1950s and 1960s, man-made rinks were set up at various playgrounds. Splashboards were installed around the tennis court at Winn Brook and the basketball court at Grove Street. Today, the Belmont Department of Public Works continues the practice by flooding the low-lying land along Concord Avenue at Cottage Street. The rink is open to the public at no charge as long as seasonal temperatures hold.

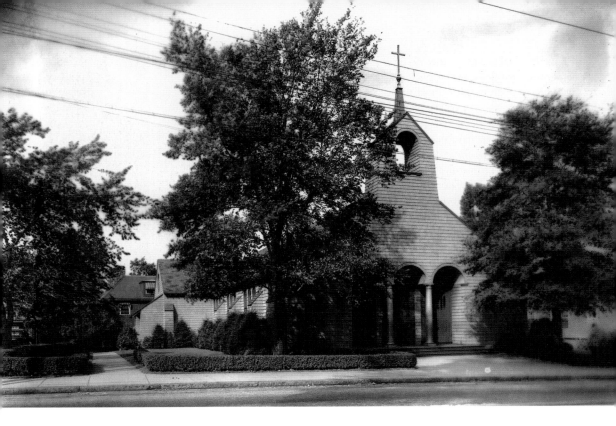

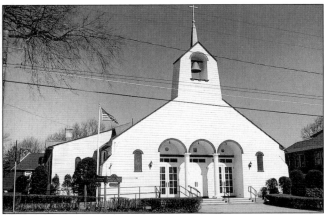

O ur Lady of Mercy Parish was established in 1926 by Cardinal William O'Connell, with Fr. Charles Maguire being named the first pastor. In May 1927, the Belmont Street property was purchased, and architectural plans were prepared by Maginnis and Walsh, designers of the Lombardy Romanesque–style wooden church. A more substantial structure was planned to replace the temporary chapel. On Christmas morning in 1927, the first Mass was conducted, and the opening hymn, "Our Lady of Mercy," written by the organist and her sister, was sung to commemorate the occasion. Expansion followed, including the building's enlargement, the construction of a parish center, and the addition of a parking lot. In 2004, the church was named on the list of closures by the Archdiocese of Boston. Its 78 years of service ended in December 2004.

Waverley Oaks, part of the 59-acre Beaver Brook Reservation, received its name from a group of giant trees said to be the oldest of their species on the North American continent. Those trees were mostly gone by the 1920s, but the name remained. The covered pavilion just inside the Trapelo Road wall of Waverley Oaks has seen more than 100 years of history. It shaded visitors to the park from hot summer sun and sheltered picnickers from showers. Between 1902 and 1906, the Boston Elevated Railway Company ran a trolley line from Waverley Square to Waltham. The pavilion provided an ideal place in which to wait for the next car. The pavilion and its shady trees have survived the changes both in town and at the park.

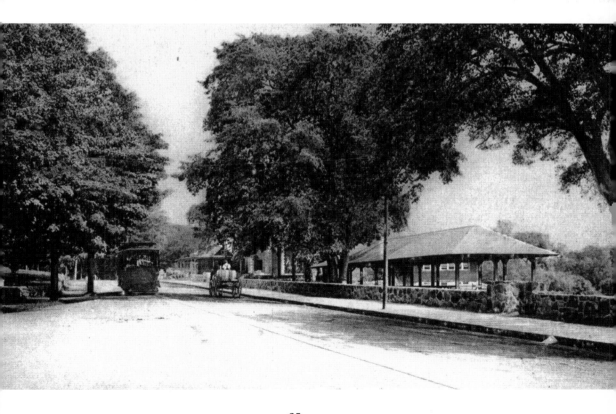

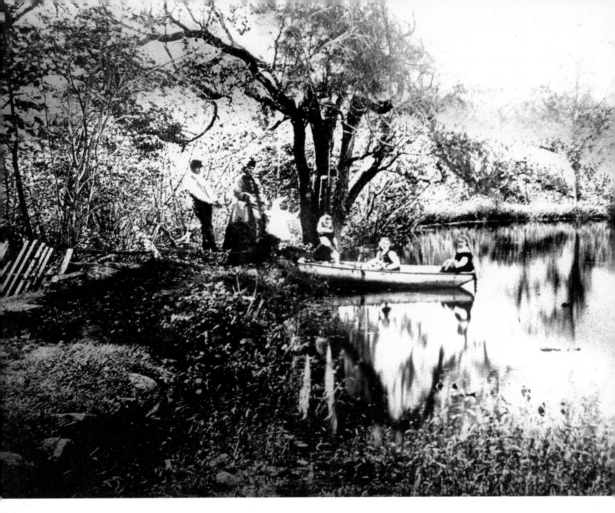

In the 1870s and 1880s, families enjoyed boating and canoeing on the ponds along Beaver Brook on Mill Street. The upper Mill Pond and the lower Duck Pond, or Handyside Pond, together with Beaver Brook, became part of Beaver Brook Reservation in 1893. Boston families took the trolley out to enjoy a day here in the country. A beautification project on the property celebrated its 100th year. During a visit to the ponds today, one can observe all kinds of leisure activity, from picnicking and feeding the ducks to jogging, cycling, walking, birding, and enjoying the trees and flowers.

This photograph was taken on the 200-acre Bellmont estate. Eleazer Preble's original landscaping was added to by subsequent owners, including John Cushing and Samuel Payson. Wealthy men once practiced the art and science of "gentleman farming," cultivating a variety of flowers and trees of rare and exotic species. The grounds also boasted a deer park, a fenced-in area for pheasant, and a two-acre flower garden. The 14 greenhouses and conservatory kept a staff of gardeners busy year-round.

Chapter 2

CHANGING TIMES

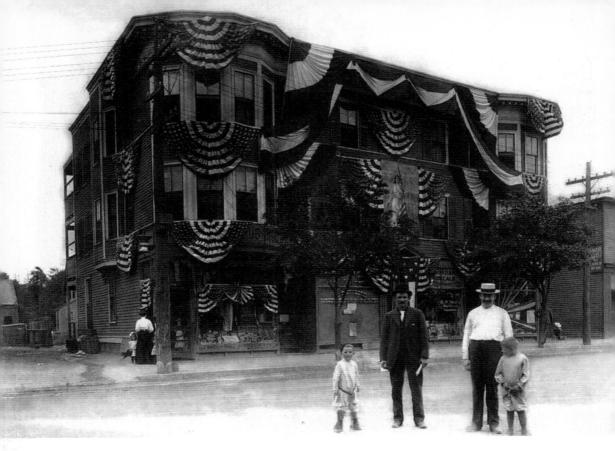

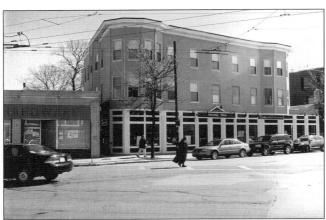

The Daly Block is patriotically dressed for the Fourth of July celebration in 1914. Matthew Daly (in the straw hat, with his son) was the original owner of the building and property before its sale to Alexander Corbett (in the suit). Early tenants were D. Butterick, who sold butter, eggs, poultry, tobacco, and confections, and Ripley Real Estate and Insurance. For a long time, the building housed Corbett's Drug Store, a fixture in Waverley Square, operating as a family business until 1998. Bowing to pressure from national chain stores, the pharmacy, formerly one of a dozen family-owned Belmont drugstores, closed. Today, nearby McLean Hospital uses part of the space for outpatient services.

Named for prominent citizen Josiah Kendall, the Kendall School opened in 1914 and served a population of elementary students. The beautiful grounds were managed until 1946 by custodian Oscar Duncan. Closed in 1981 due to declining enrollment and Proposition $2^1/_2$ cutbacks, the space was leased to various groups by the town and continued to operate as the Kendall Center for the Arts. On April 9, 1999, a call from a neighbor alerted the fire department, which arrived shortly before 10:30 p.m. to find the structure engulfed in flames. The four-alarm blaze, still smoldering the next morning, prompted officials to declare the building a total loss, and demolition of the once beloved neighborhood school soon followed. Construction of a senior center was proposed for the site.

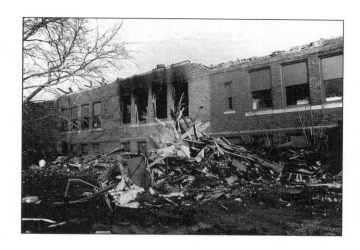

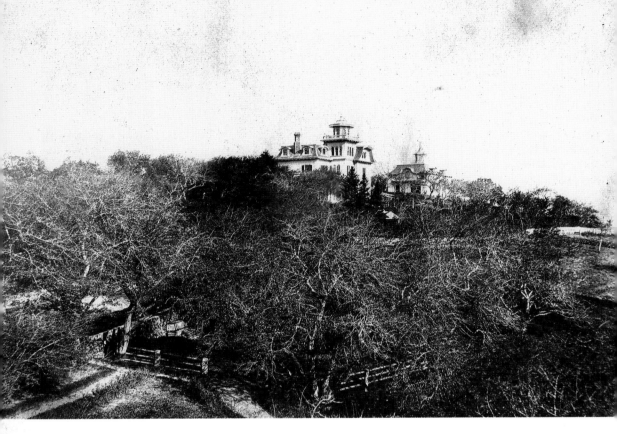

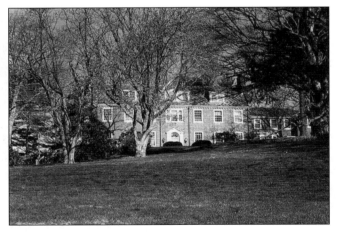

After the arrival of the railroad, Belmont became a popular place for summer visitors. Sea captain James Homer, uncle of artist Winslow Homer, built his elegant summer home on Belmont Hill property he bought from the Wellingtons. From it, he commanded a clear view of Boston. Elisha Atkins began renting the Homer house for the summer in 1857 and purchased the property in 1865. Every May 1, the Atkins family arrived by carriage from Boston to take up residence and returned to the city each fall. Granite gateposts installed by Captain Homer and the view of Boston remain as evidence of that era. The house was demolished, however, and a fine Georgian Revival home was built on the site for Helen and William Claflin in 1926.

S. S. Pierce opened its Cushing Square store in the 1920s in a building designed by Thaxter Underwood. The store was noted for the delicacies it stocked. The petits fours were a requirement at many tea tables in town. The meat department was the bailiwick of Cobb, Bates, and Yerxa. A fleet of snappy horse-drawn wagons accomplished the transport of goods both from the Boston store to Belmont, and then to homes here. Before the store closed, the horse-and-wagon had been replaced by trucks and in-store shopping. A variety of businesses have occupied the space on the corner of Trapelo Road and Common Street since. Today, a Chinese food takeout, a jeweler, an auto parts store, and Chicken Express reflect the changing times.

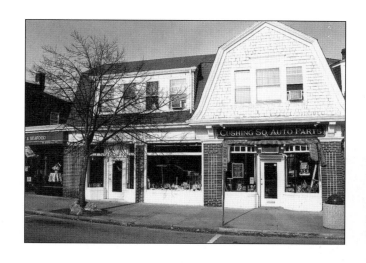

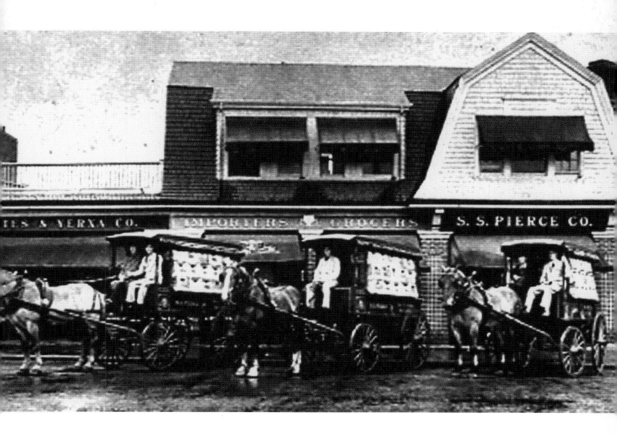

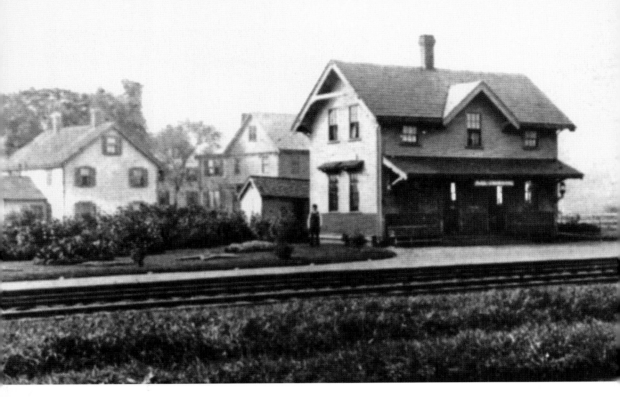

Hills Crossing was the name given to this area along Brighton and Hittinger Streets. In 1843, the Fitchburg Railroad extended the tracks, which were once used by the Tudor Ice Company to transport ice cut from Fresh Pond, through the property of Henry Y. Hill, a local farmer. Over the years, the once rural landscape has been home to businesses of many types. Past commercial enterprises include Carl Norberg's egg business, with its 10 henhouses, and Westinghouse, whose building, erected in 1950, is now occupied by Cambridge Plating Company. More recently, both the DiGiovanni brothers and the Cellucci family replaced homes with office buildings. Today, the real estate resembles neither its rural nor its residential beginnings.

The Winthrop L. Chenery Elementary School opened in 1924 on Washington Street. Two years later, at the far end of the site facing Oakley Road, the Belmont Junior High School was erected. The two separate buildings were linked together in 1969 following the closing of the elementary school. Shortly thereafter, the Chenery name was transferred to the junior high school. Family and friends gather to witness the graduation exercises of the class of 1933. On July 8, 1995, crowds again gather, this time to witness flames shooting through the roof of the school. Firefighters, who arrived just before midnight, fought to contain the blaze that gutted the original Chenery wing. Following the suspicious fire, the school was completely demolished and rebuilt before being reopened in 1997.

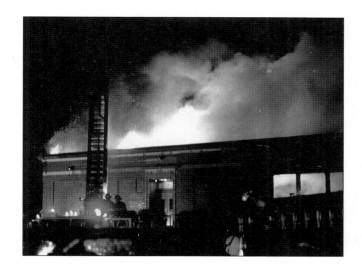

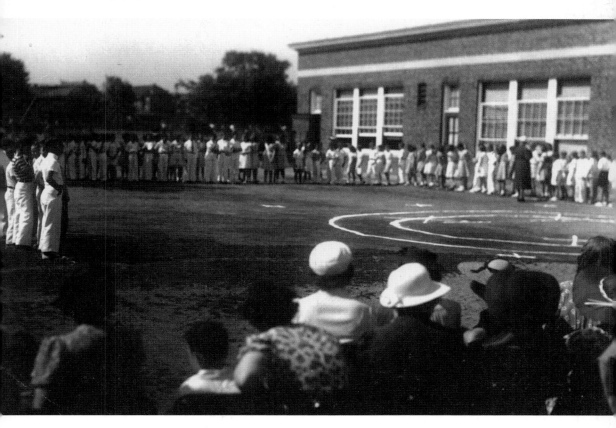

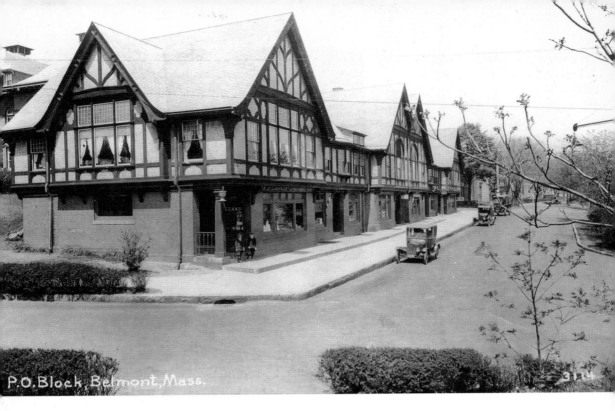

P.O. Block, Belmont, Mass. 3114

Known by nicknames such as the old Masonic Building, the Block of Shops, and Olive's Block, this attractive Tudor-style block of stores was a Belmont Center landmark for many years. It was designed by Eleazer B. Homer and erected in 1899 for about $22,000. The first level was brick. The second was plaster over wood, with exposed beams. La Bonte's and then Olive's Drug Store anchored the Concord Avenue corner. The post office and the telephone exchange were housed in the building. Nelson's Tailoring, a cobbler, Pino's Barber Shop, Belmont Market, and Harvard Trust Company were also tenants at various times. On the second floor were meeting rooms used by various fraternal and community organizations. Bowling alleys and a billiard room occupied the basement of the building. It was the area's first community center.

Belmont Savings Bank, an early tenant, purchased the building in 1950 and operated there until replacing the structure with the present two-story Colonial brick building and attached parking garage. A clock that hung over the entrance escaped the destruction and was relocated to the branch office in Cushing Square, where it remains today. On April 29, 1968, the first "bite" was taken out of the roof of the 175-foot-long, 40-foot-wide landmark, clearing the site along Leonard Street after 79 years. The demolition foreman captured local sentiment, saying, "It breaks my heart to see such a pretty building torn down."

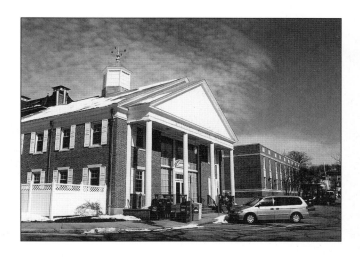

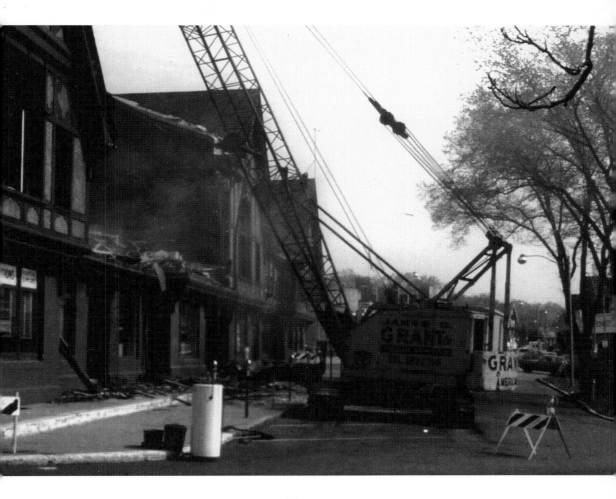

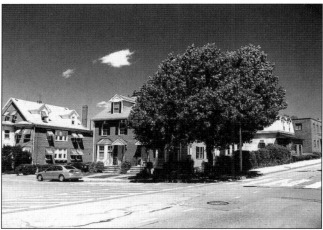

In 1874, the Cambridge Brick Company opened a yard on land originally owned by the Richardson family. Parry Brothers bought and expanded the operation to include an engine house, steam boilers, brick sheds, barns, and a boardinghouse situated on a 20-acre site around the clay pit. A merger with New England Brick Company in 1900 boosted production to 15 million bricks a year, until the clay ran out and the operation was abandoned. An oil painting by Harold Dunbar shows a rare look at the surroundings. Giovanni "John" Rigazio purchased the property between 3 Underwood Street and Concord Avenue from the brick company in 1926. Both the house at 3 Underwood and the barbershop at 105 Concord Avenue, once the brick company office, incorporated the local brick in their construction.

A familiar landmark is the former Belmont Center station, built by the Boston & Maine Railroad in 1908. At that time, the granite underpass was also erected, which eliminated the at–grade crossing by elevating the tracks and changing the grade 21 feet. The fieldstones used in the construction of the station were gathered from nearby Belmont Hill by David Thomas, a local farmer. Passenger service was suspended in 1958. Area protests prompted its resumption in 1974. Although the platform still accommodates commuters on their way to North Station in Boston, the building itself has been home to the Belmont Lions Club since 1955. Members continue to maintain a community focus and add holiday spirit with their annual Christmas tree and wreath sale each December.

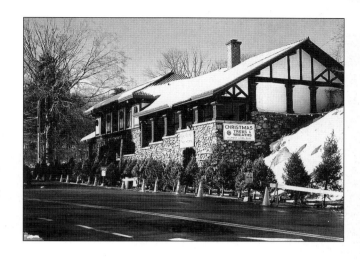

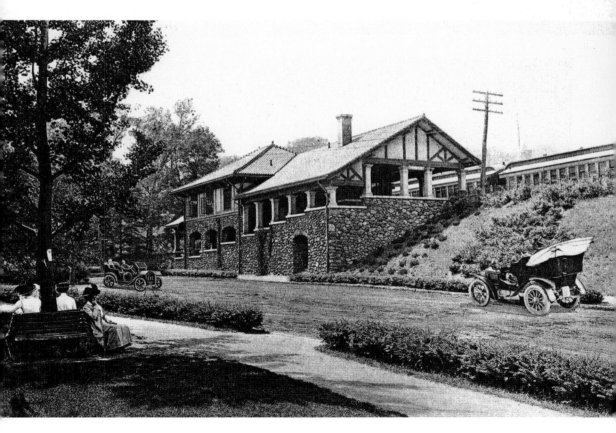

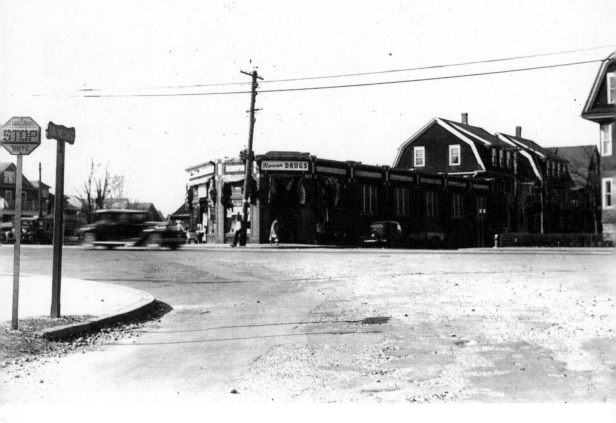

Rosen's Drug Store occupied the corner spot at the junction of Grove Street and Marion Road where they meet at 185 Belmont Street. William E. Rosen took over the business from his former boss, Louis C. Sumberg. Over the years, the block also housed a food store and a cleaners. William Rosen was the kind of druggist Hollywood makes movies about. He knew his customers in the neighborhood and understood the concerns illness creates. He was known to make emergency deliveries, accept payment over time, and check up on families affected by sickness. The Rosens still own the block, and Belmont Medical Supply, an expanded version of the business, now entirely fills it.

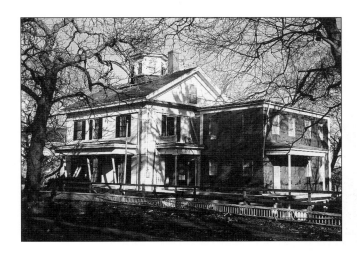

Built in 1850 at the corner of Pleasant Street and Alexander Avenue, this handsome Greek Revival structure was the residence of Rebecca Locke and her second husband, John Alexander. Dr. Alexander served as postmaster at Wellington Station from 1855 to 1859. The house is in the Pleasant Street Historic District, along with 43 other properties. These homes represent a well-preserved collection of architectural styles of the 18th and 19th centuries and line both sides of this section of Old King's Highway, which still connects Waltham and Arlington. Formed in 1975, the district is governed by the Belmont Historic District Commission, which was created in 1972 and charged with preserving unique characteristics of structures, maintaining or improving settings, and encouraging new buildings to choose complementary designs.

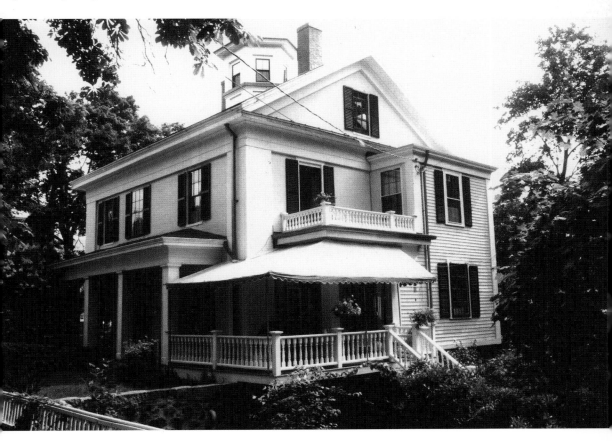

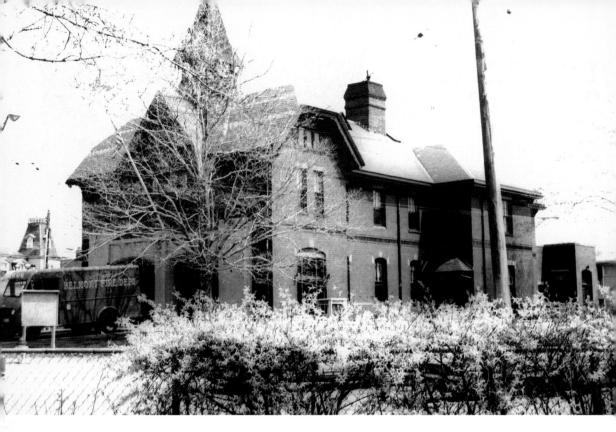

In 1906, by vote of the town meeting, the original Daniel Butler School, at the junction of Waverley Street and Trapelo Road, was turned over to the Belmont Fire Department for temporary use. The building had been constructed in 1873, but abandoned when a new school was built in 1900 to accommodate the increasing student body. In 1926, the hall on the second floor of the Waverley building was remodeled into sleeping quarters for the firemen. In late 1908, the town voted to build a fire station on Fairview Avenue. In 2003, after 97 years in temporary quarters, the fire department moved into new temporary quarters in the town yard on C Street, awaiting construction of new headquarters approved in April 2004.

In the 1800s, Holiday Farm, depicted below in a watercolor by Nelson Chase, occupied a parcel of land between Concord Avenue and Somerset Street. The property was owned by Henry Clarke, a wealthy paper manufacturer. Clarke, who also raised prize Jersey cows, was credited with introducing the Brown Swiss breed to the United States in 1869. He imported a bull and seven cows. In addition to the main house, the farm comprised an elaborate building complex. A bowling alley and billiard room were contained within the stable. The property was subsequently purchased, first, by Charles Fairchild and then, in 1892, by the Atkins family. All that remains of Holiday Farm is the barn's stone foundation, which provides the walls of a private sunken garden.

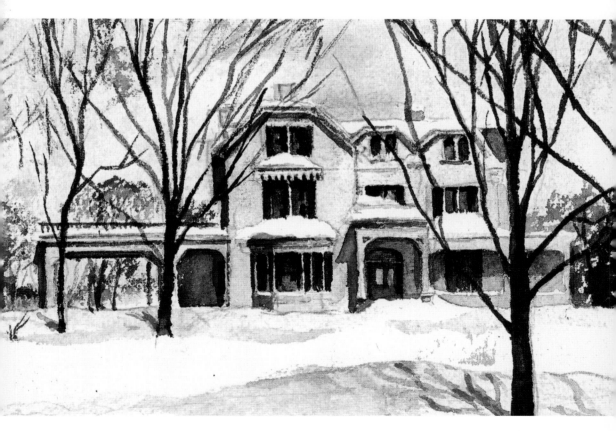

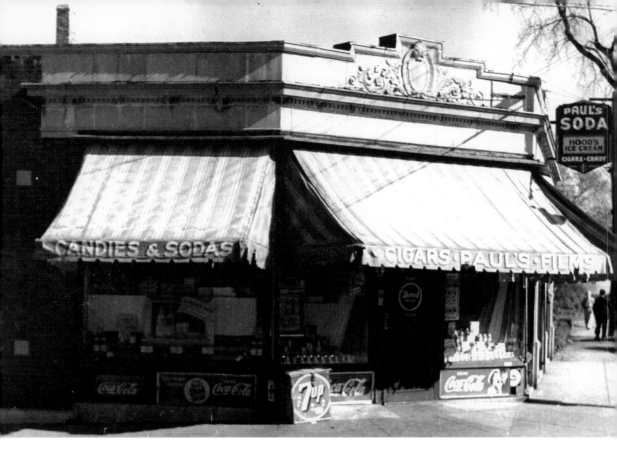

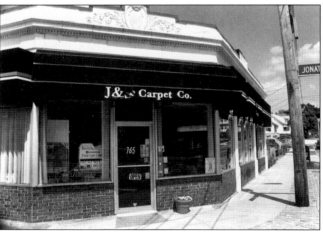

For many years, the corners of Belmont Street and Jonathan Street were anchored by Paul's Spa, Belmont Provision, and Belmont Cleaners. Paul's, as everyone called it, was a neighborhood variety store. Belmont Provision, a grocery store, and Belmont Cleaners completed convenient one-stop shopping on the opposite corner in the 1940s and 1950s. During World War II, when gasoline rationing and the scarcity of tires curtailed driving and regular customers were rewarded with first call on sugar and other foodstuffs in short supply, these local stores were essential. A childcare facility (now essential to our lifestyle), a physical therapy center, a different variety store, and a carpet and flooring shop currently occupy the storefronts. Some of the architectural details have been preserved.

When Bellmont Mansion was razed in 1929, the components of its circular library remained in town. Contoured bookcase over cabinet units rose from floor to ceiling. Their glass door panels were curved and divided by semicircular ebony moldings. The closets below were made of redwood, the shelves above of ebony, and the doors of mahogany with a veneer of English oak. For a time, the disassembled room was in the care of the Society for the Preservation of New England Antiquities. Since 1983, it had been stored in a town building on Concord Avenue. The historical society recently received unrestricted title to the library, and on May 4, 2004, it was moved off town property and evaluated by a conservator. Final disposition of

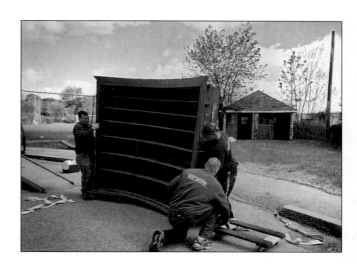

the room will be determined after a thorough study of possibilities.

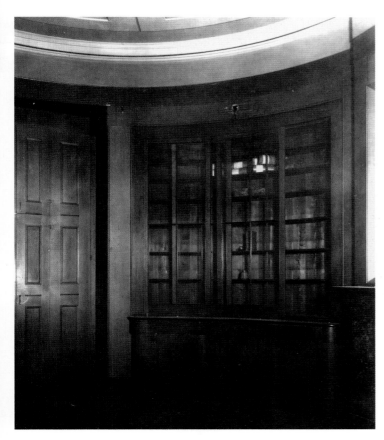

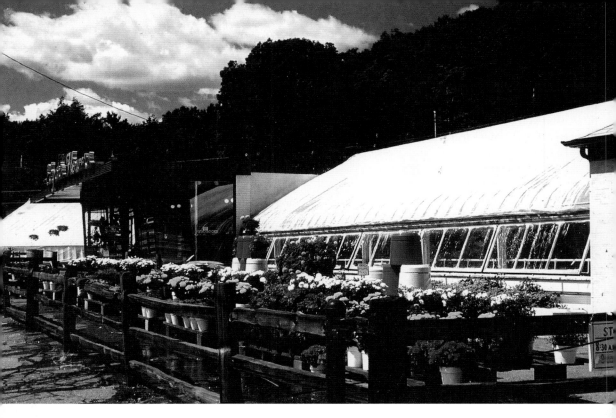

Edgar's, established in 1884, was Belmont's second-oldest business. The business grew to include nine greenhouses, a parrot named Polly, a flower shop where many prom corsages were purchased, and a conservatory. The business was sold in 1948 after the death of Rose Edgar, who had continued the business following her husband's death in 1907 with the help of her son. Pearson and Quint were the new owners. In 1967, Theodore Pearson ran the business, claiming to have the largest collection of indoor tropical foliage plants in New England. Negotiations to tear down the greenhouses and build a supermarket began in 1985 with Shaw's. Subsequently, a Star Market was constructed on the site. Currently, it is a Shaw's Supermarket.

Emilie Frances Edgar, pictured in 1897, spent her childhood in the family home next-door to the family business, Edgar's Florist. The demand for flowers and plants grew with the town, and Edgar's quickly became one of the largest businesses in the early 1900s, importing bulbs and seeds from all over the world. When she grew up, Emilie married Alexander Corbett, owner of Corbett's Drug Store, a neighboring Waverley Square business.

Chapter 3

FACES AND PLACES

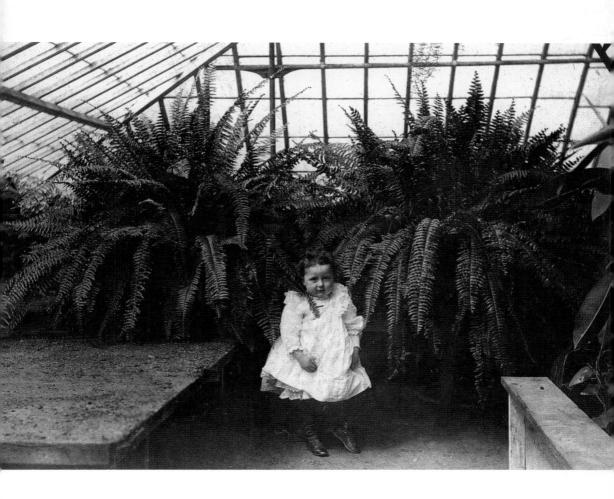

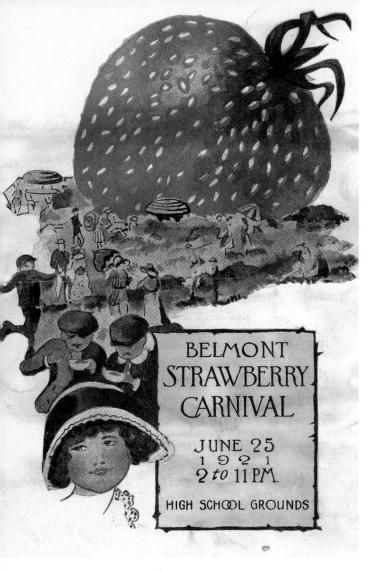

BELMONT STRAWBERRY CARNIVAL

JUNE 25
1921
2 to 11 P.M.

HIGH SCHOOL GROUNDS

Strawberry festivals have been a popular celebration in Belmont since 1859. On June 25 of that year, the doors to the first festival were opened. A 25¢ admission was charged. Prizes were awarded to growers of the finest berries, a "bountiful repast was served to all," and strawberries and ice cream were sold for 10¢ a saucer. The evening concluded with an auction of the best berries, the first-prize basket selling for $6.50. Simple but popular, the event has been repeated year after year. The festivals have moved from the First Church in 1859 to Eleazer Homer's field, the town hall lawn, the high school grounds, and most recently, the Belmont Woman's Club, where second-graders are treated to strawberries and ice cream, recalling the delicious tradition.

The Belmont Dramatic Club was
organized in 1903 at the Loring
Underwood home. The first play
performed was *School,* and the second,
in February 1904, was *Rosedale.* The
80 charter members of the club paid
dues of 50¢. The membership grew to
more than 900 in the 1950s and
1960s. Going to a play was an event
for audiences, and closing-night cast
parties were legendary. Despite
assorted interpersonal problems and
near disasters, the show always went
on. The Belmont Dramatic Club, the
second-oldest continually running
community theater group in the
nation, celebrated its centennial during
the 2003–2004 season. A production of
The King and I inaugurated the
festivities of 100 Years of Applause.

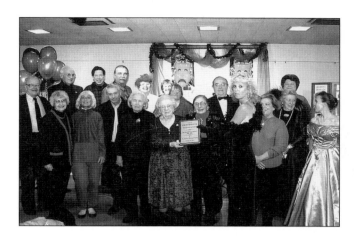

On his way to revisit the battlefields at Lexington and Concord in 1824, Gen. Gilbert de Motier Lafayette stopped at Wellington Tavern, arriving in a coach drawn by four white horses, accompanied by a brass band. Col. Jeduthan Wellington then drank cider with him, reminiscing about Revolutionary War days. The centennial of that occasion was celebrated in 1924 on the lawn of the town hall annex, the former site of the tavern. Ralph Morton Diaz, Guy Dennet, and Jacob Hittinger appear above, second, third, and fourth from the left, respectively. In 2000, descendant Count Gilbert de Pusy Lafayette (left) relived the experience with Jefferson Wellington Haase (center), a descendant of the colonel, and Richard Betts, town historian. No cider was served; however, one of the glasses used on that first occasion was displayed.

This greenhouse, once part of the Atkins estate, stands as a reminder of Belmont's agricultural past. Ben Adams (in the straw hat) discusses flowers made ready for outdoor planting with the gardener, while young Helen and Ted Atkins look on. Today, the Belmont Garden Club's Greenhouse Group maintains a wide variety of plants under glass. Its entries over the years in area competitions have brought the club both distinction and numerous awards. Records have been kept since the early 1950s, when Helen (Atkins) Claflin offered the use of the hothouse on her property to create an educational opportunity to grow and propagate flowers. Current members participate in a weekly work schedule that includes making soil, washing pots, and watering plants. The group meets every Tuesday from October 1 to May 31. (Above, courtesy of Belmont Garden Club.)

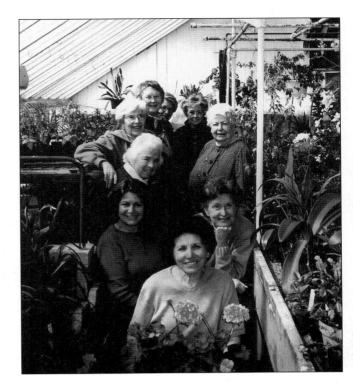

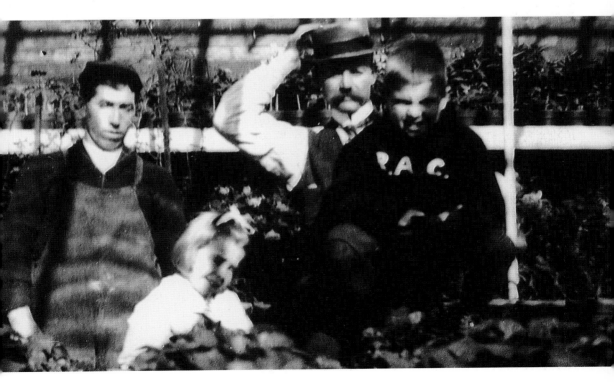

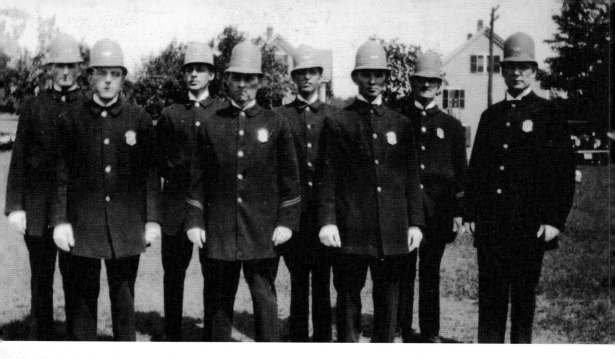

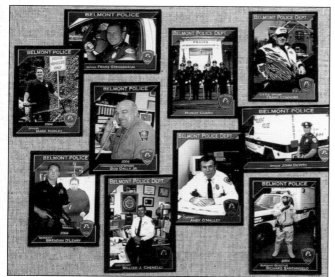

The Belmont Police Department was originally quartered in the town-owned Tramp House, on Concord Avenue, which included five jail cells in the basement. David Chenery Jr. was named constable and moved into the building, becoming the first police chief. Following the construction of the town hall in 1882, the department was relocated there until a new headquarters was built across the street in 1931. Today, the force has grown to 46 members and includes 4 women. In May 2004, patrolmen began issuing officer trading cards. Children who collect all 44 are entered into a drawing to win a bicycle donated by Wheelworks. The contest is designed to encourage Belmont youth to recognize the policemen and feel more comfortable when approaching them.

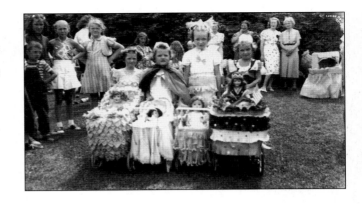

Little girls and their mothers looked forward to the Doll Carriage Parade, a special summer playground event in Belmont for many years. Crepe paper was rolled, ruffled, pleated, stretched, scalloped, and poufed to decorate carriages, dolls, girls, and occasionally the family dog. Many hours of patient labor by mothers, aunts, big sisters, and neighbors went into preparations. Prizes were awarded for prettiest, best combination of girl and carriage, and most original. Boys carried on the kickball, dodge ball, softball, and baseball games free from female interference on Doll Carriage Parade Day. Regular playground events included handcrafts, sports, and field trips. Campouts, cookouts, and field day were featured each year, as well as other special events, all of which included costumes, activities, and refreshments.

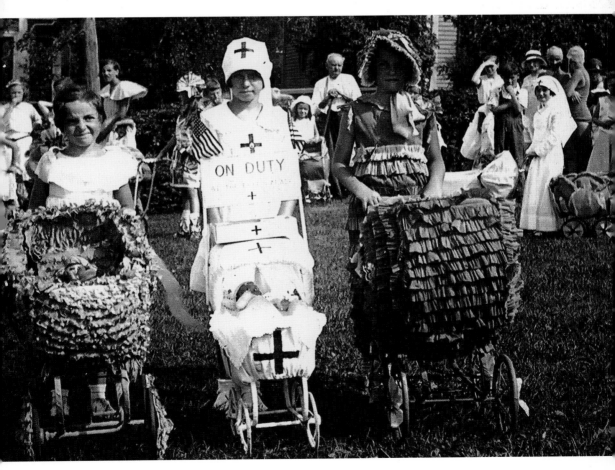

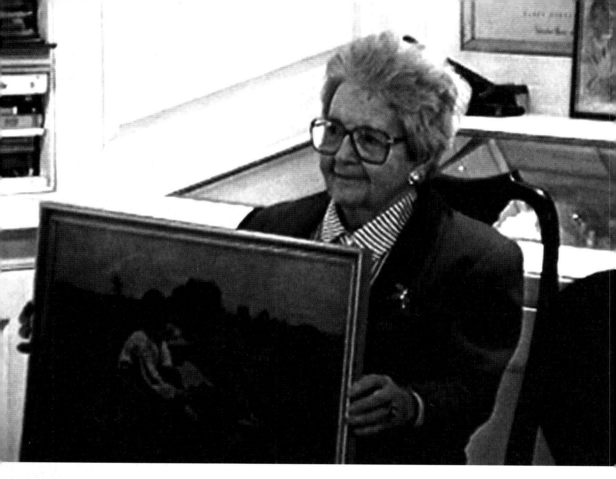

Mary Keenan holds a print of Winslow Homer's 1874 painting *Boys in a Pasture*. Her father, Patrick J. Keenan of 253 Waverley Street, was seven years old when he posed for the artist. John Carney, a neighbor, was the other model. The boys were paid 75¢ a day by Homer, some of which was spent for treats at Russell's Store in Waverley Square. Patrick Keenan grew up to be a patrolman in Belmont in 1906. John Carney became a cabinetmaker. The setting for the painting was a meadow off Somerset Street. The front section was sold in 1966 to the Belmont Hill Club. The back acreage was donated to the Massachusetts Audubon Society for Highland Farm Wildlife Sanctuary. Local boys reenacted the scene in 2001.

The Madrigal Singers was formed in 1980 by Shirley Laman, choral director, who elevated the organization to the level of the other high school music programs. It was the first organization of its type entered into the Massachusetts Choral Competition Festival. Soon, other schools followed Belmont's lead. The Belmont High School madrigal group has won many trophies in competitions since its inception. Members wear Elizabethan costumes, enhancing the dramatic effect of the music, which is performed unaccompanied and self-directed. As its reputation as an accomplished singing group spread, the group received many invitations to entertain. It has sung at Filene's during the Christmas holidays and for many town organizations including the Belmont Garden Club, the Belmont Historical Society, and the Belmont Woman's Club.

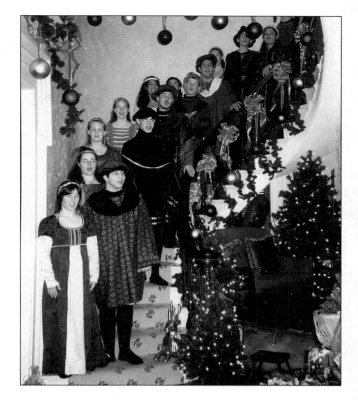

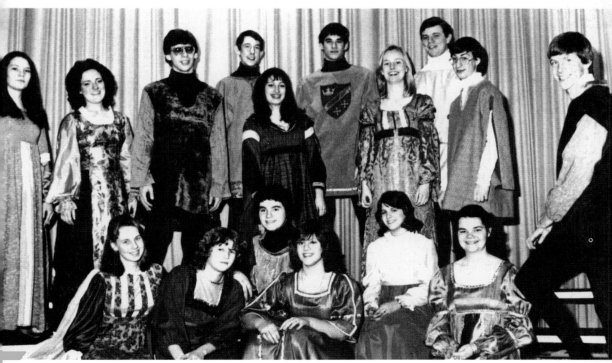

M embers of the Belmont Historical Society staff an open house in the original town clerk's office in November 1974. Over 500 members of the public enjoyed the two-day exhibit that featured the painting *The Centre of Belmont about 1900,* by local artist Nelson Chase. The artwork, four feet tall and five feet wide, reflects the architectural training Chase received at the Massachusetts Institute of Technology before graduating in 1917. It was commissioned by the historical society and was featured in the first of several events to celebrate America's bicentennial. Delores Keefe (right), the present-day town clerk, takes a break from her duties to pose with fellow employees Peter Harrington and Mary Ellen Barker in the office at the town hall, where prints of the painting may be purchased.

The national Rotary was founded in 1905. The name refers to the fact that meetings rotated among members' businesses. Rotarians are business and professional leaders who take an active role in their communities. The Rotary Club of Belmont began in 1928 and included men who either worked or lived in Belmont. Women were admitted as Rotary members in 1985. On June 24, 1985, three women joined the Rotary Club of Belmont: Kay Karagianis, Gloria Kezerian, and Margaret Loder. Rotarians give back to the community through special projects. They encourage high ethical standards, provide humanitarian service, and help build goodwill and peace worldwide through Rotary International. "Service above Self" is the group's motto.

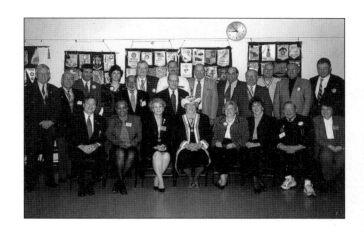

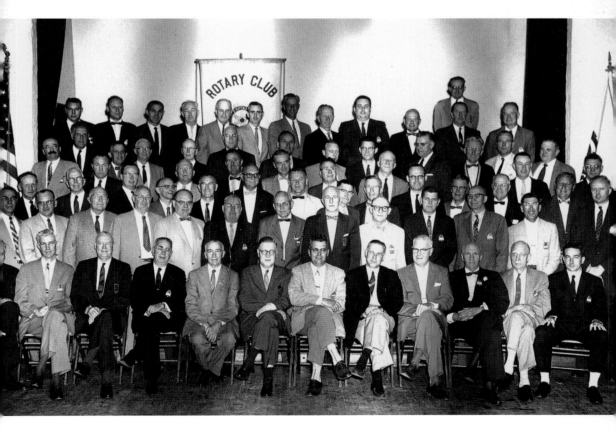

In April 1959, the above youngsters celebrated National Library Week with activities including a puppet show and story hour at the Underwood Library, on Pleasant Street. The library, built in 1921 as Belmont's first freestanding public library, was a gift to the town from Henry Underwood. In 1965, the Belmont Memorial Library was built on Concord Avenue and included a separate Children's Room, which continues to attract families with offspring of all ages. Various programs are scheduled each week, including story time, a book discussion group, a craft hour, and a sing-along. The dedicated staff is kept busy meeting the needs of all age groups and offers services that greatly contribute to the town's overall sense of community.

Fire Chief William Hill (below) stands at attention beside the new car purchased from the local Chrysler-Plymouth dealership on Belmont Street. Dealer Stuart Fay is pleased to deliver the shiny replacement and stand for a photograph, which documents the sale. Just one month before his June 5, 2004, retirement, longtime Chief William Osterhaus (above) reenacts the scene in front of the Harvard Lawn station, the only one to remain undisturbed. His service, which spanned 32 years including the last seven as chief, ended following a successful campaign to win town-wide support for funding and building two modern stations. Groundbreaking for the newly designed headquarters building on Trapelo Road was set for early 2005.

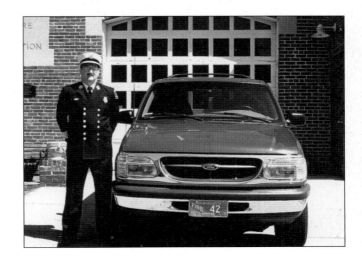

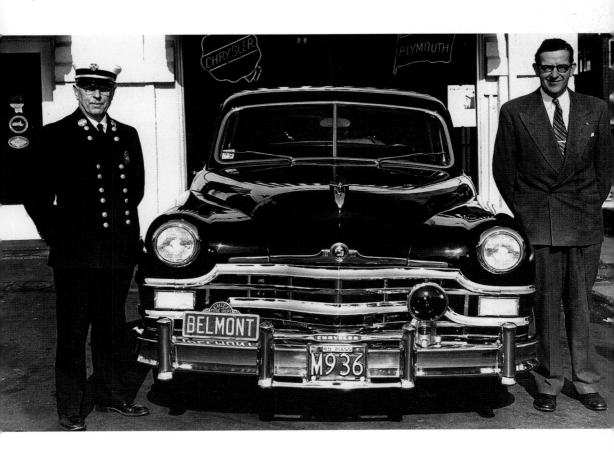

The Belmont Woman's Club sponsored numerous fund-raisers when it purchased the William Flagg Homer house in 1922. One of these, Society Circus, in June 1927, pulled out all the stops. Seen above are some of the plants and flowers for sale on the club lawn. On the driveway, in front of the main door to the house, pony rides were held. Sideshows and booths selling various carnival fare were located in the barn that stood on the property. Bands entertained, clowns roamed the grounds, and a good time was had by all. More recently, the clubhouse and grounds hosted a middle school concert, Silhouettes and High Tea, and a clambake to raise funds to maintain the historic property. (Courtesy of Belmont Woman's Club.)

Exercise was a social and recreational activity enjoyed at the turn of the last century. At the start of the new millennium, the Belmont Council on Aging provides exercise classes for physical fitness at its temporary location, 23 Oakley Road. Although the Belmont Senior Center opened in December 1998 in the former parish hall of Our Lady of Mercy Church, the search for a permanent site has been ongoing since 1980. In addition to exercising, seniors are offered a full schedule of events and activities. Instruction is offered in everything from computers to quilting, travel, movies, and celebrations for every occasion.

Thanks to the generosity of Helen Claflin, the Belmont Memorial Library, which opened in 1965, includes a room designed to house a growing collection of local history, prompting the reactivation of the Belmont Historical Society. The space was custom built and furnished in the style reminiscent of a period reading room. Twenty large cabinets hold written and photographic records, atlases, maps, and newspapers. Town reports, school yearbooks, and countless genealogies fill the shelves. Murals painted by Nelson Chase depict *The Town of Belmont in 1859,* and *Colonel Jeduthan Wellington's Farm and Tavern*. The collection is in the care of historical society volunteers, who open the room to the public on a regular schedule. Today, the society boasts 300 members served by a board of directors.

In 1874, the town took its first step toward creating a highway department when it purchased the 6.5-acre parcel of land along Concord Avenue for a gravel pit. In 1877, a "tramp house and stable" were erected on the site, which also housed road master and constable David Chenery Jr. The present town yard, off C Street, was purchased in 1928 and originally included a blacksmith shop. Today, Peter Castanino, a town employee of 22 years and head of the newly created Belmont Department of Public Works, poses in the sign shop with the familiar "Entering Belmont" sign, which greeted travelers along Pleasant Street. Targeted by vandals, the sign was removed and repainted by the highway department, in whose custody it remains for safekeeping.

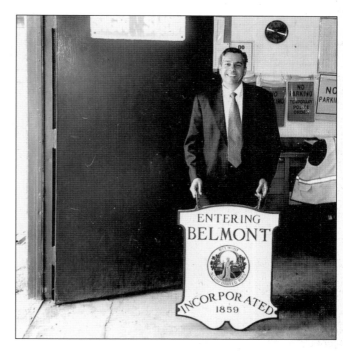

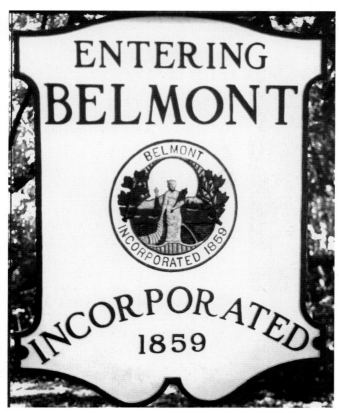

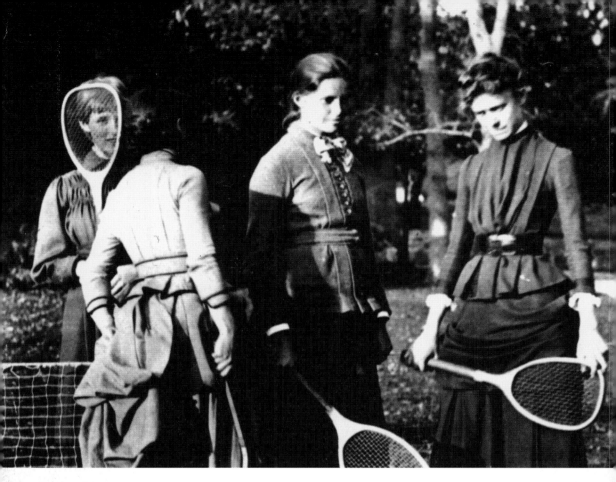

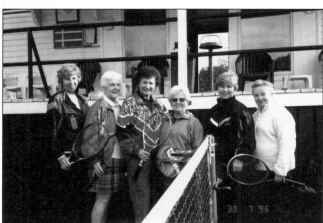

Tennis garb has changed over the years, but the Belmont Tennis Club has endured. In existence since 1884, it was incorporated in 1889. Although 4¢ would remain in the treasury, the club accepted the offer of land on Thomas Street, part of George F. Blake's property, for an annual rental of $20. The club has been there ever since. It had served only gentlemen until 1893, when every second Wednesday was set aside as ladies' day. Another successful move, made in 1894, was to discontinue the practice of supplying free tennis balls. In 1898, the club purchased the rental land. The Belmont Tennis Club celebrated its centennial in 1984, alive and well, with a membership of more than 100 and a long waiting list. (Below, courtesy of Marilyn Papazian.)

Belmont's youth performs acrobatic feats as part of a calisthenics routine. This photograph was produced from a series of never-before-seen images captured on glass slides and donated to the Belmont Historical Society. The collection reflects ordinary activities made extraordinary by the passage of time. Today, the historical society's archives include current events, which are considered "history in the making," in an attempt to accurately capture lifestyles in the new millennium for future generations.

Chapter 4

DIFFERENT STROKES

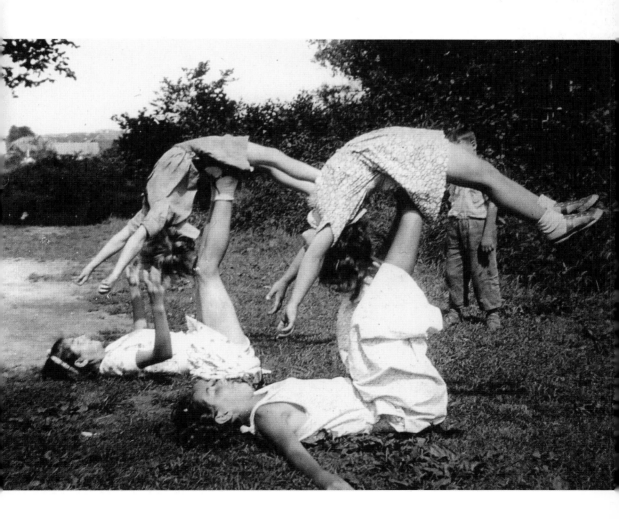

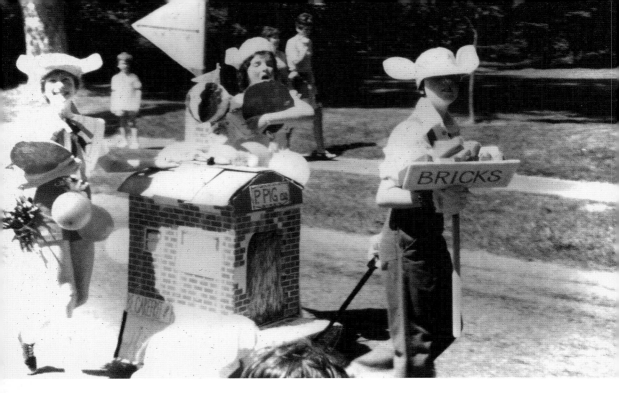

Holidays and significant anniversaries—Memorial Day, the town's centennial, and the nation's bicentennial—have traditionally been celebrated with parades in Belmont. Marching bands and units of all ages representing organizations, town departments, schools, churches, and branches of the military have turned out to participate. Marchers are joined by motorcycles, bicycles, and usually a convertible or two transporting dignitaries and less-hardy parade participants. The bigger parades have included floats commemorating both history and current events. The early parades featured festively decorated horse-drawn wagons and carriages. Assorted motor vehicles now provide the power for the floats. Balloons and flags from the 1959 parade and three little pigs from the Belmont Memorial Library contingent in the 1976 parade capture the spirit of fun surrounding these occasions.

Reuben Richardson was a member of the extended Richardson family who owned and farmed large tracts of land around Belmont. The pictured residence remained in the family for many years. Originally built at 168 Grove Street, the house was moved in the 1940s, when residents voted to purchase the property to enlarge the Grove Street playground. It was not uncommon at the time for even large buildings to be moved by horsepower over the course of many days. Relocation casualties to the house were the rooftop turret removed and the granite steps left behind on Grove Street, now leading nowhere. Today, the house stands at 196 Grove Street, in close proximity to its original site.

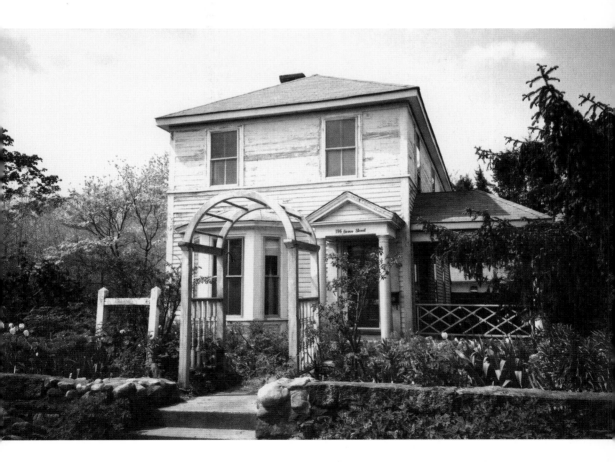

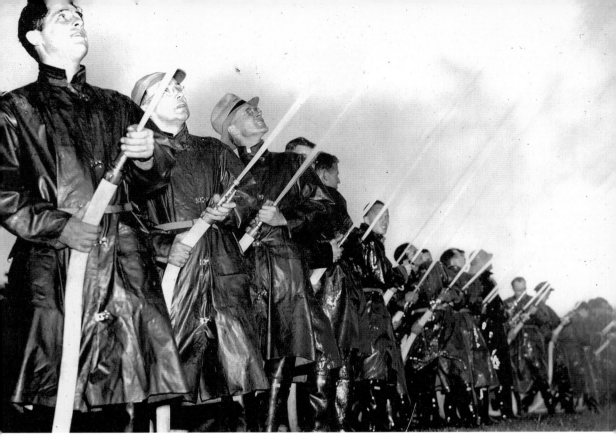

During wartime, firemen eligible for the draft entered active military duty, creating a shortage of staff on the Belmont Fire Department. In March 1941, the public safety chairman made plans to form an auxiliary fire service under Belmont's civil defense program. To ensure adequate service, a group of 87 volunteers divided into four companies began the necessary training, with the first drill session in May. These residents, known as auxiliary firemen, freely rendered their services, responding to all multiple alarms and calls for special assistance. The group above practices the skills necessary to handle the heavy hoses in the event of an emergency. Although manpower and equipment was much improved, the job continued to provide a challenge during the multiple-alarm blaze at Ross Dairy, off Moraine Street, shown below.

The Boys' Club of Belmont was founded in 1962 by George Moran, who was regarded as more of a social worker than a typical policeman. The 400 Club for teenagers was then established in a building at the corner of Flett and Trapelo Roads. Without committed support, however, the club was short-lived. Friday, February 27, 2004, marked the grand opening of a new teen center at the Daniel Butler School. Under the supervision of Rick Chasse, Belmont's youth service coordinator, the center is available on Friday nights from 7:00 to 10:00. Chasse negotiated with the school committee for the use of the gymnasium for sports and the auditorium for games and snacks. Belmont's DARE organization provided money for the initial equipment, which included a Ping-Pong table, stereo, big-screen television, volleyballs, and basketballs.

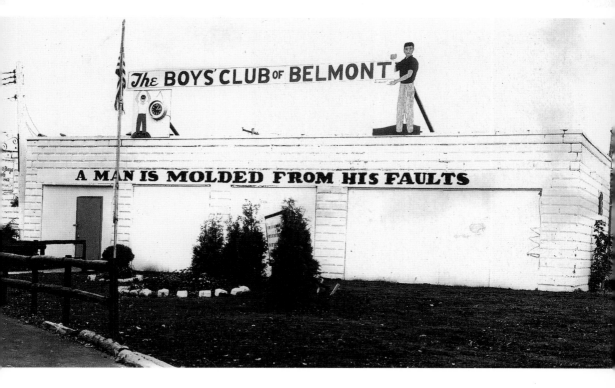

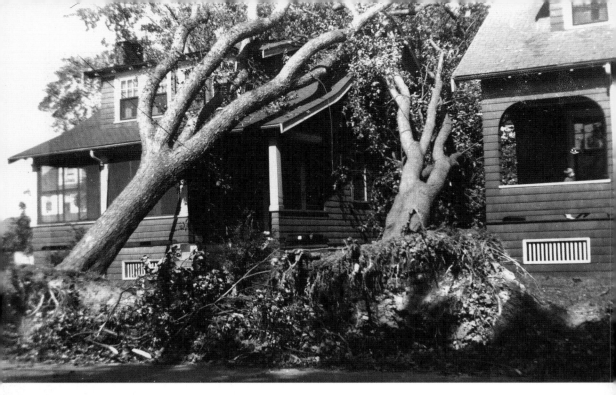

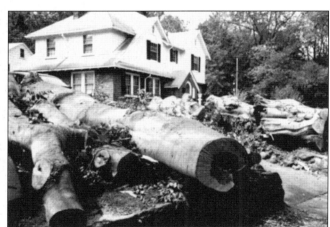

On September 21, 1938, a general-alarm bell was sounded in Belmont, mobilizing 40 legionnaires in uniform in response to the most destructive storm to hit New England, the Hurricane of '38. Belmont lost an estimated 1,500 trees on public property and countless more on private property all over town. Damage to the local area exceeded $250,000. On August 19, 1991, some 53 years later, Hurricane Bob again targeted Belmont's trees, toppling a 200-year-old European copper leaf beech onto the roof of the house at 21 Common Street (below). The cost of the town-wide cleanup following the storm totaled $375,000.

The Brighton Street School was built in 1842 on land that became Belmont in 1859. The bell in the belfry rang out in celebration of the incorporation. This was a two-room schoolhouse, with classrooms upstairs and down. Gil Frost remembers that the draft from the windows was fierce in the back row and that water came from an outside pump. The school closed in 1921, and the 60 pupils moved to new rooms in the Homer School. The school was torn down in 1925, resulting in the vacant lot on Brighton Street. The lot is the oldest piece of public land still owned by the

town. Plans for occupancy of the site call for a house to be built by Habitat for Humanity.

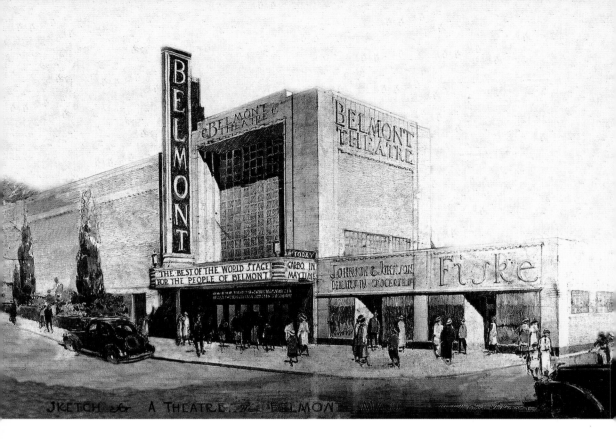

JKETCH OF A THEATRE AT BELMONT MASS

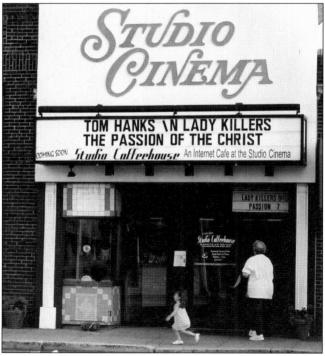

STUDIO CINEMA

TOM HANKS IN LADY KILLERS
THE PASSION OF THE CHRIST
COMING SOON *Studio Coffeehouse* An Internet Cafe at the Studio Cinema

LADY KILLERS 9½
PASSION 7

Movies began in Belmont in 1914, when the Unitarian Society of Waverley showed "community moving pictures" in Waverley Hall. In 1919, ground was broken for a new block of stores on the corner of Trapelo Road and Beech Street. "A handsome moving picture theatre of the most modern type" was to be included. The Strand Theatre's premiere in 1921, starring Bebe Daniels and Buster Keaton, attracted overflow audiences. It was not until 1929, however, that the first talkies were shown to patrons, who were admitted to evening shows for 25¢ and matinees for 11¢ and 17¢. The so-called "Barn" changed ownership in 1965, and the theater was renamed the Studio Cinema. The architectural drawing above shows a grand new building that, in hindsight, was appropriately left on the drawing board.

Complicated tambourine routines, staples of vaudeville and minstrel shows, were great crowd pleasers. In the 1940s, the art of the tambourine arrived in Belmont, thanks to the efforts of Emil Linn. Linn perfected routines to the accompaniment of a 78-rpm record, while his daughter Janet lifted and replaced the needle at appropriate moments. Variety shows presented by various organizations in town featured rousing renditions of "Stars and Stripes Forever," which always brought the house down. More recently, town meeting opened with the crowd pleaser. Linn has passed his secrets to Sandra Kendall, and so the tradition continues. The routines have been included in more than 300 performances by the Kilt Club, Tempo Belmont, Tempo II, the Arlington–Belmont Chorale, and the Belmont Ecumenical Youth Choir and Tambourine Team, pictured above.

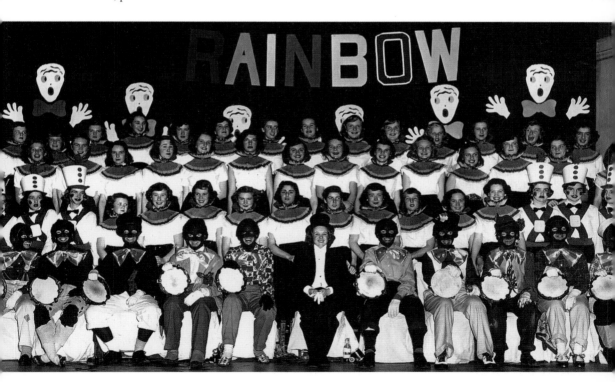

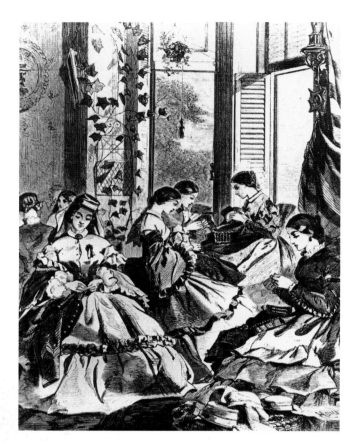

Women sewing has been a theme in both art and life for a very long time. Winslow Homer sketched his cousins and their friends *Making Havelocks for the Volunteers* in the front parlor of his uncle William Flagg Homer's house, on Pleasant Street. This sketch appeared on the cover of *Harper's Weekly* on June 29, 1861. The havelocks, extensions at the back of a cap, protected the Civil War troops from sun and rain. More recently, members of the Belmont Woman's Club have been working on the Linus Project to provide blankets to comfort hospitalized children. Their sewing circle also takes advantage of the light in the front parlor of the same house, owned by the club since 1922.

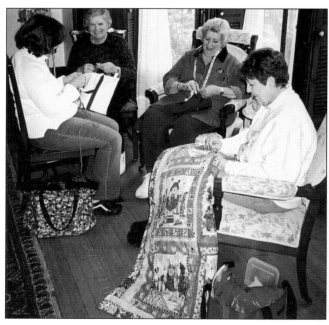

The Clark Street bridge (below) once served the area known as Clark Hill, which was named for the family that originally owned and farmed the land. The Clark homestead, built in 1760, still stands at 59 Common Street, and from this location, young son Peter Clark saw the smoke and gunfire at the Battle of Bunker Hill in 1775. The wooden bridge was built in 1843 to preserve access to and from Pleasant Street. In 1931, repairs were needed, and after legal claims as to who should bear the expense, the railroad did the work. The railroad maintained the bridge until the 1970s, when all railroad bridges in the state were turned over to the Department of Public Works. Although the bridge was demolished in 1995 and

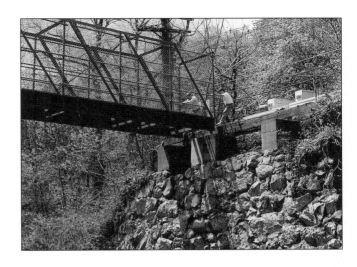

replaced with the footbridge shown above, the controversy remains over vehicular access.

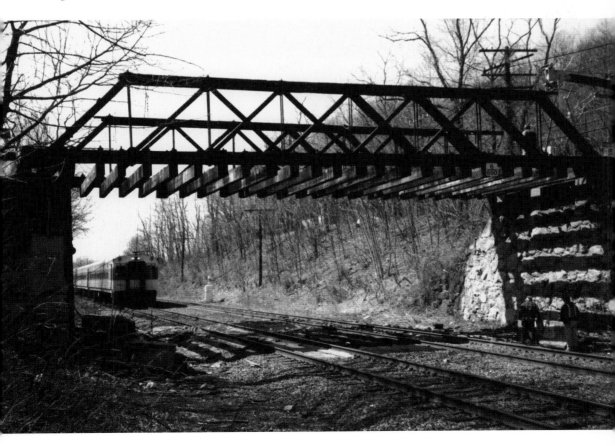

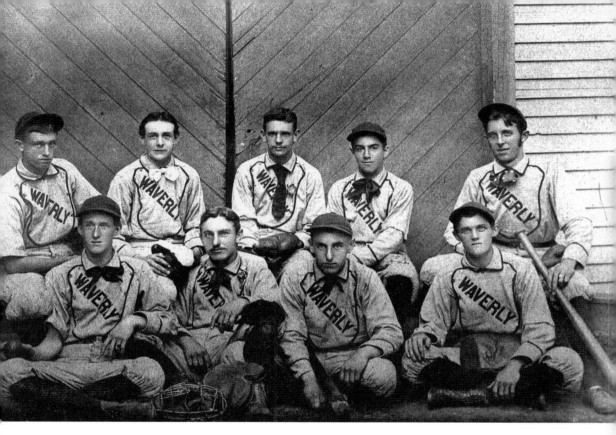

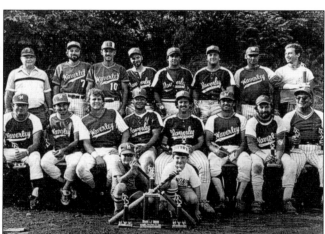

This early photograph shows a baseball team composed of boys from neighborhoods around Waverley and suggests the division that existed between youth from that area and other sections of Belmont. Over the years, the rivalry was intense, as championships were decided and bragging rights awarded. A Waverley team has continued this winning tradition under the sponsorship of the Waverley Insurance Agency. The family-owned business holds the distinction of being the longest team sponsor in the state in the fast-pitch softball league, with more than 25 years of commitment. The team has won numerous titles under coach Ralph Sabatino, including eight championships between 1980 and 1997. Today, countless trophies line the window of the insurance agency, at 493 Trapelo Road. (Below, courtesy of Ernie D'Agnelli.)

The Beth El Temple Center congregation had its first home in Belmont in 1945, when a large house at 220 Lexington Street was purchased. It was enlarged in 1947 to include an auditorium. The first High Holiday services were then held in the ~~~~~~~ own building. In 1951, ~~~~~~ ollman accepted the ~~~~~ vices for 37 years until ~~~~~~ long, continued ~~ ger building ~~ Concord Avenue at ~~ was purchased, and ~~ June 1954. A ~~ family farmhouse ~~ hed, and there ~~ rides on the

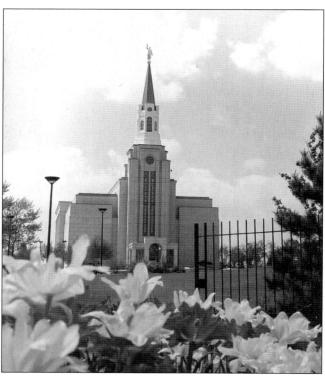

The Arlmont Country Club began in 1921, when golf was played on fenced-in greens to keep away the cows that grazed on the shared land. The original building was built as a locker room, with later additions including a dining room. In the 1970s, the Mormon Church researched building sites for its growing congregants in the western suburbs and purchased a 16-acre thickly wooded parcel of land on Belmont Hill. Despite opposition from neighbors, construction of a meetinghouse was completed in the mid-1980s. In 1996, groundbreaking began for a three-story cathedral-like structure on the remaining nine-acre parcel. Opening in August 2000, the Mormon temple was expected to draw an estimated 300 worshipers a day from across New England.

The Belmont Pet Shop, at 434 Common Street, opened in 1949. Owners Cal and Valerie Colotti sold small animals of all sorts, as well as supplies to care for them. A West African Mangebey monkey named Chi Chi was a resident attraction in the shop for more than 30 years. Her antics and escapades are legendary. Bob and Loretta Thomas bought the shop in 1984 and relocated across the street to 447 Common. Pet grooming is a service now offered, in addition to the small critters and accessories. A bright colored parrot named Elvis is the current attraction, available for sale to the right home. (Below, courtesy of Donna Colotti.)

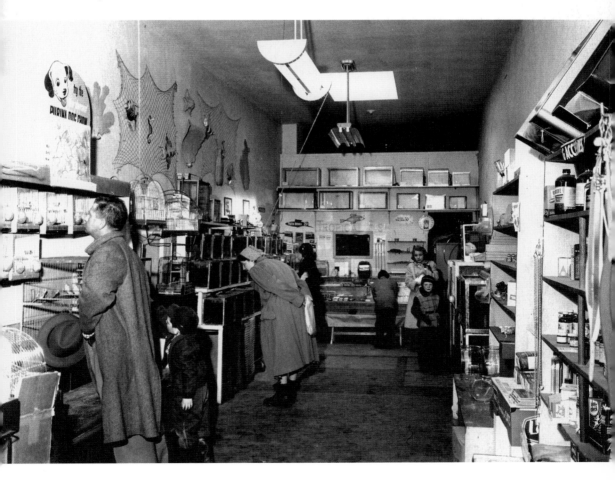

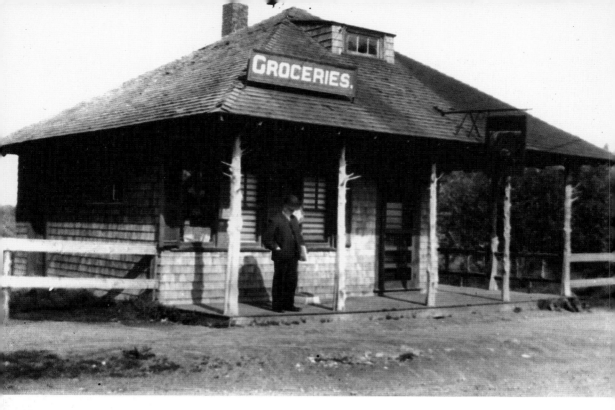

Charles F. Merrow came from Cambridge and established the Merrow Country Store in 1905. Located on the southwest corner of Trapelo Road and Common Street, the store was the first commercial building in Cushing Square. Merrow later owned the A. A. Adams Store in Belmont Center and Payson Park Market in Cushing Square. In 1914, the Merrow Country Store was moved up Common Street and converted to a small home. This made room for the block of stores that now occupies the original location. Again, in 1947, the building was moved, altered, and enlarged. It is now a private residence on Creeley Road.

The indigenous people living on the land we call Belmont comprised a tribe of approximately 500 Pequosette Indians. In 1638, the settlers bought the land from them for 13 pounds, 7 shillings, and sixpence. The relationship between tribe and town was commemorated with a parade float in 1959. The Native American presence in the area is documented by the abundance of arrowheads and stone axes, and by the remains of an ancient amphitheater used for ceremonial occasions.

Chapter 5

LASTING LEGACIES

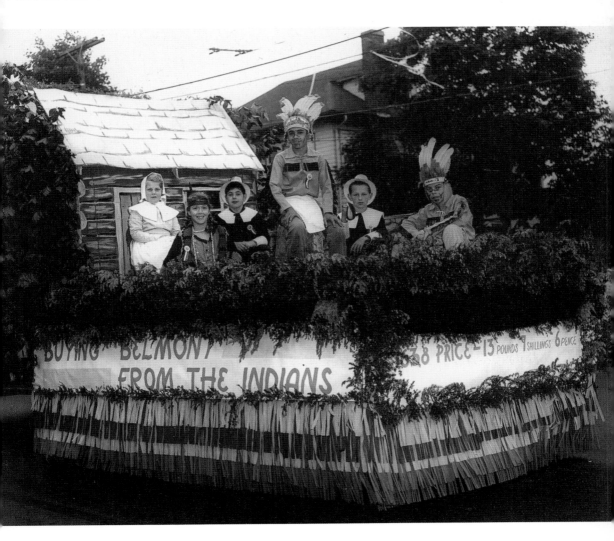

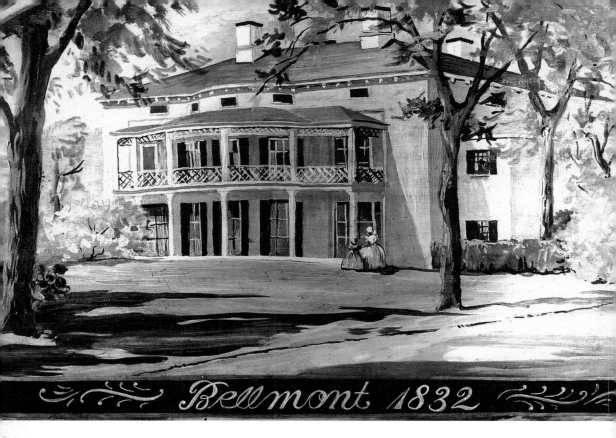

Bellmont 1832

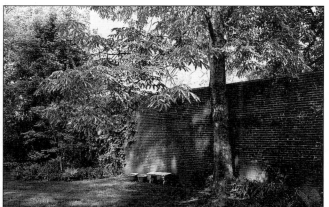

John Perkins Cushing contributed substantially to the incorporation expenses of Belmont, with the provision that the town adopt the name of his 50-room mansion, Bellmont, pictured here on a tray decorated by Nelson Chase. Bellmont was built between 1832 and 1840 at a cost of more than $115,000. The original estate covered 118 acres. One of its features was a flower garden that covered nearly two acres, said to have been laid out by Eleazer Preble, the previous owner of the property. He built two high brick walls to protect the garden from the winds. The east wall still runs through the backyards of homes on Preble Gardens and Townsend Roads. It is 11 feet high, 13 inches thick, 165 feet long and capped with lead.

Thaxter Underwood stands beside a cannon in May 1933. A second gun, in front of "the Shack" in Cushing Square, joined its mate in 1959, when the building was torn down. The cannons were once part of the artillery aboard the USS *Constitution*, the oldest commissioned warship afloat in the world, launched in 1797. The cannons became a part of Belmont's unique history when the Boston Navy Yard gifted them to the town, granting a petition made by the board of selectmen in 1931. The undercarriages were recently rebuilt by 10th-grade students at Minute Man High School as a class project, and relocated to the delta on Common Street by members of the highway department, under the direction of the Belmont Historical Society, in 2002.

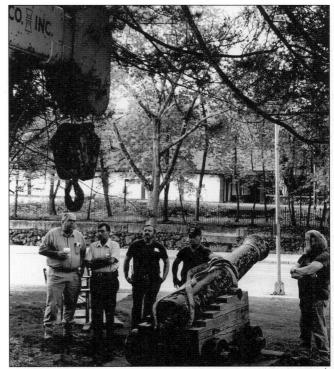

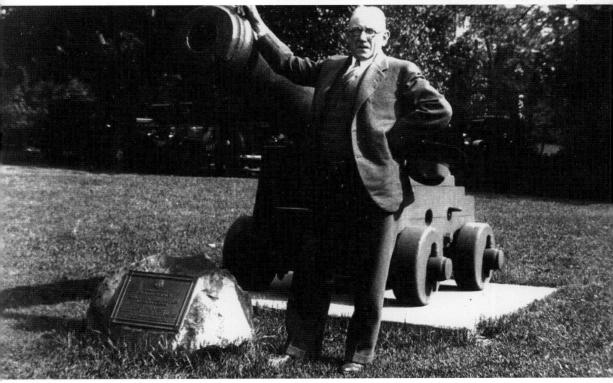

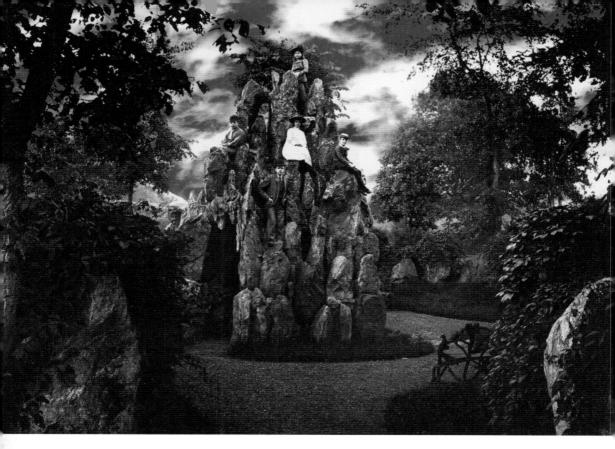

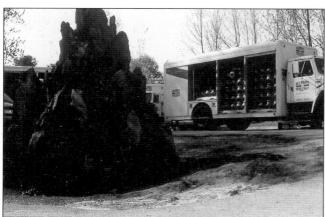

Belmont Springs Water Company is the town's oldest continuing business. Once an estate owned by Samuel Green, the property was purchased by George H. Cotton for a summer home. He began the commercial development of the springs in 1876, when the business was incorporated. A rock enclosure, or grotto, was built around the spring by John L. Sullivan's sparring partner. In the 1870s and 1880s, Bostonians enjoyed carriage excursions to the Cotton estate to admire the landscaped gardens and drink a silver dipper full of pure, fresh spring water. During World War II, the company supplied water used to stock lifeboats. In the postwar years, Belmont Springs became the largest producer of distilled water, used for modern technology, in the region. The business was sold to Coca-Cola in 1969.

The Morton house is shown entering Belmont in 1966, escaping demolition in the path of the Route 2 widening. The highway project added lanes in both directions, but 51 Belmont homes were lost in the process. The Architectural Heritage Foundation purchased this historic dwelling and planned to reassemble it, adding preservation restrictions for future protection. The house, originally built in 1858, stood in West Cambridge. The next year, the newly incorporated Belmont claimed the property. An irregular boundary line was straightened in 1933, when the turnpike cut through the Morton land, causing the house to fall within the jurisdiction of Arlington. Today, the house enjoys its new address, at 30

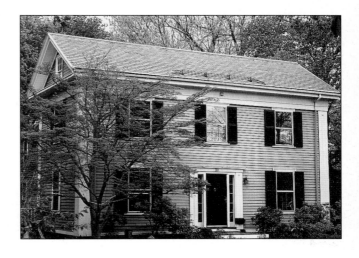

School Street, standing as an example of the important role preservation can play in protecting the historic assets of a community.

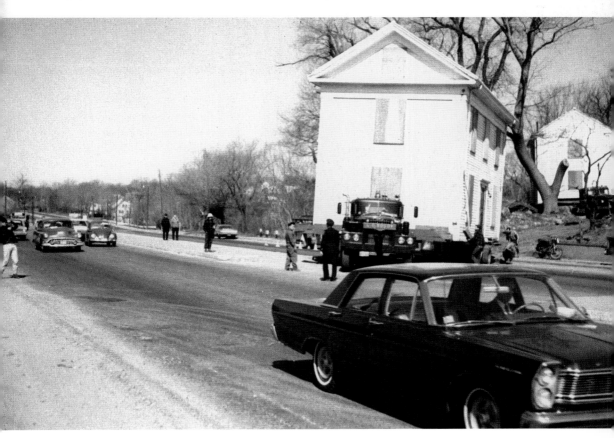

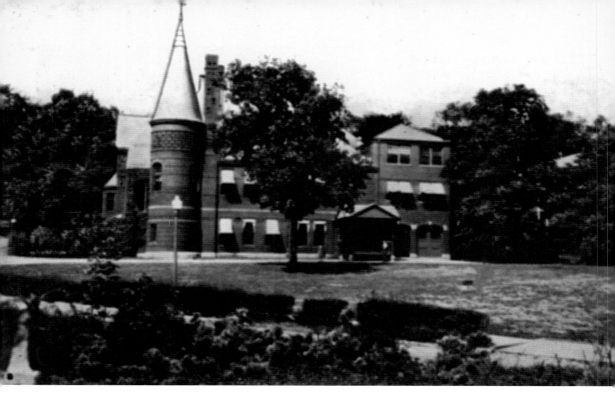

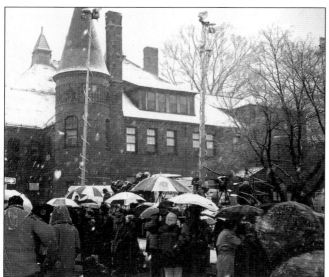

Dedicated on June 22, 1882, this impressive Queen Anne–style building, designed by prominent architect Henry Hartwell, was built and furnished at a total cost of just under $50,000. Early uses of the space included police lockup, selectmen and school committee rooms, fire department storage, drama club performances, the Belmont Savings Bank, and a public library. The town hall is considered by many to be the most beautiful building in Belmont. A 2002 outdoor celebration, seen below, sparked local controversy and attracted regional media attention when friends and neighbors gathered to "Welcome Home Our Olympic Heroes," Mitt and Ann Romney, following the winter games in Salt Lake City, Utah. Days later, at his home on Marsh Street, Romney announced his candidacy for governor.

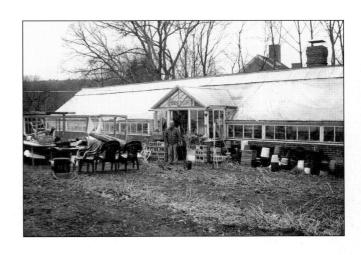

Located on the former Underwood estate, this greenhouse of metal girder construction, built in 1885, is one of the oldest in the state and one of the few remaining in Belmont. Gardeners who worked for the family on the landscaped grounds and formal gardens managed a variety of plants and flowers here until the 1960s. The building's basement includes a squash court, where it is rumored that Pres. Harry Truman played a game or two. Underwood children are seen in the foreground of the *c.* 1920 photograph, taken on the property. Still standing in back of the home at 20 School Street, the greenhouse continues to be operated by retired florist Frank Curro, who each year prepares an assortment of annuals and perennials for spring sale to local gardeners.

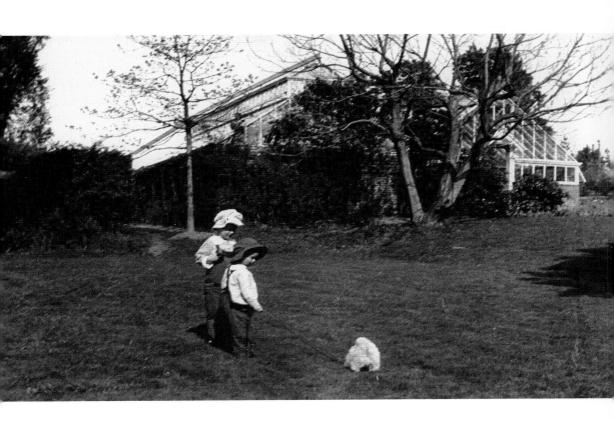

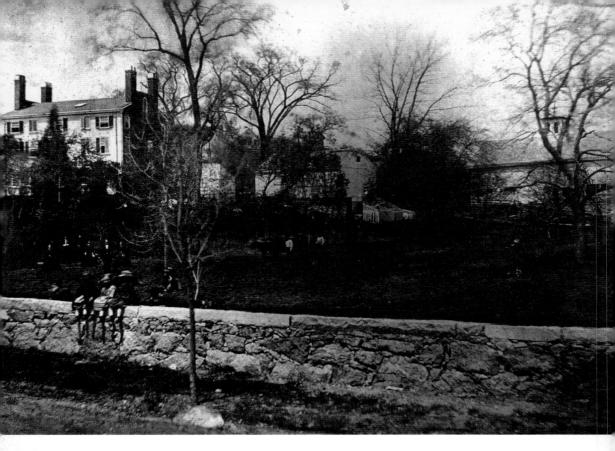

The Wellington Homestead and Tavern recalls the name of Jeduthan Wellington, whose enterprise and spirit gave a distinct name to this locality. The home was built in 1799 and was occupied by the colonel, his second wife, Elizabeth Loring, and their 16 children until the buildings were demolished to allow for the town hall complex. Jeduthan Wellington was a descendant of Roger Wellington, who came to this country from England in the 1630s. The monument placed here marks the location where he originally settled and where the family managed a large farm stretching toward Menotomy and covering the land known as Belmont Center. The farm at Wellington Hillside became a successful enterprise and at one time included 13 greenhouses and 28 acres under cultivation.

Although Belmont's five-year battle for incorporation was won on March 18, 1859, its first flag had to wait another 137 years. The flag's creation was prompted by state legislators, whose desire it was to collect a banner from each of the 351 towns in the Commonwealth of Massachusetts. In response to this request, the Belmont Historical Society designed a flag adopting the town seal, which highlights several early landmarks and portrays an agricultural theme. Historical society member George Packard poses with the finished product prior to its being transported to the state house for Flag Day on June 14, 1996. It remains on permanent display adorning the Great Hall.

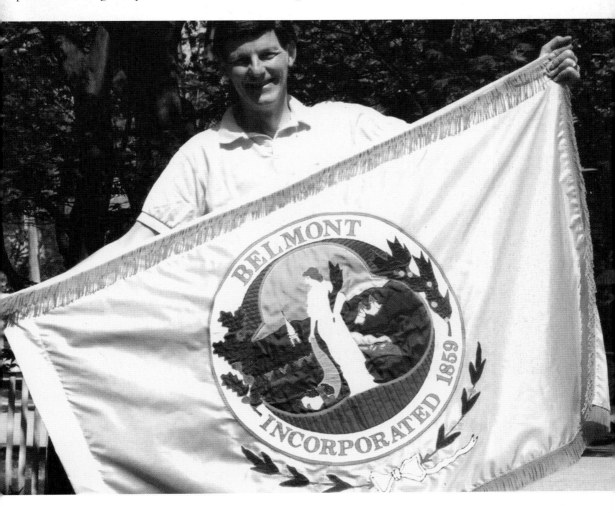

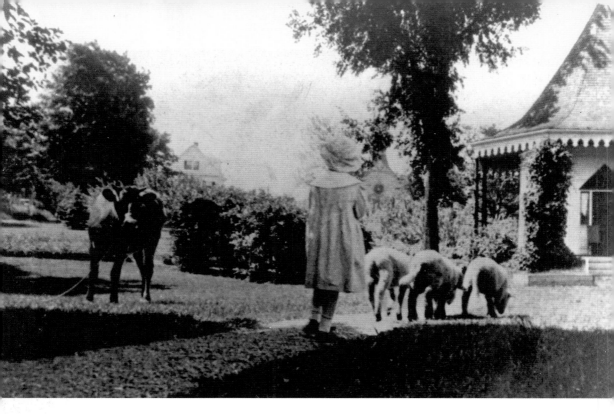

This one-room schoolhouse was constructed in the early 1840s by Samuel O. Mead and the widow of Col. Jeduthan Wellington. David Mack, Belmont's first librarian, taught class here for a short time before opening the Orchard Hill Boarding School for Young Ladies on Pleasant Street in 1853. This octagonal building was rented and then sold to the railroad for $350 for use as a depot at the Wellington Hill stop on the Fitchburg line from 1851 to 1879. Made obsolete by the construction of a larger station, it was repurchased by Mead, who moved it to his property along Concord Avenue. This c. 1918 photograph recalls its use as a summerhouse by the family, including great-great-granddaughter Margaret Underwood Wellington, pictured here.

The "old railroad station" was deeded in 1974 to the Belmont Historical Society, whose ambition it was to restore and relocate the historic landmark so the public could enjoy it. Several sites were considered before the building was moved to 2 Common Street, its current address. The task is in progress (below), as movers make their way toward the new foundation, 300 feet from its original site, on December 14, 1974. Enhanced by plantings from the Belmont Garden Club, the new site (above) undergoes fall cleanup, as sixth-grade students perform community service under the supervision of the historical society, which continues to maintain the landmark.

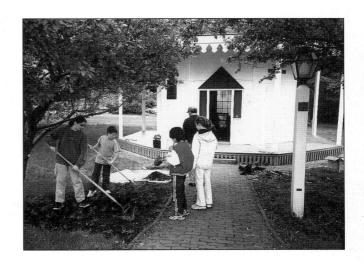

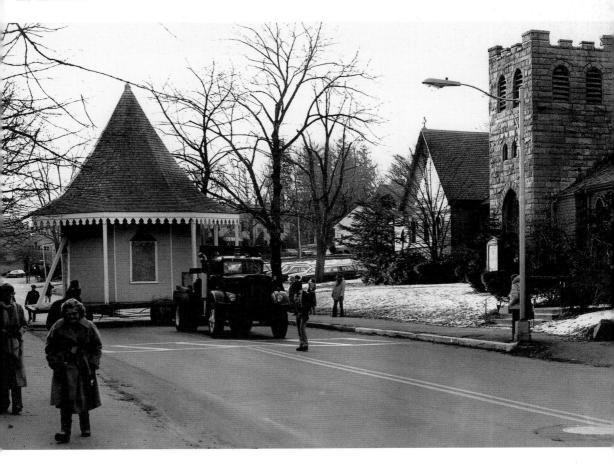

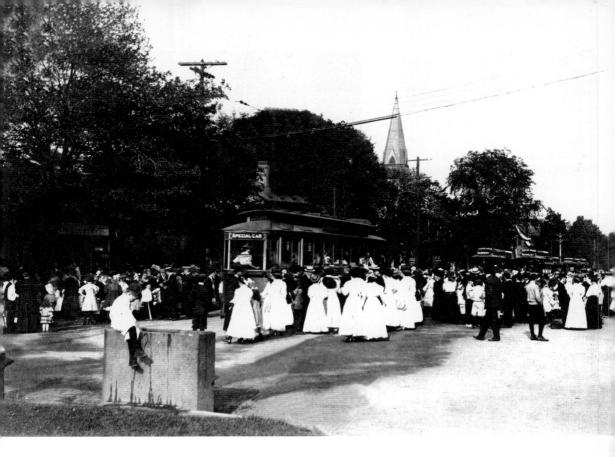

BELMONT,
1884.

In 1884, the Belmont Board of Selectmen appropriated $300 to purchase two stone watering troughs. The one in Waverley Square was placed on the grass at the corner of Church Street and Trapelo Road, but it disappeared in 1945, when the roadway was widened. It is seen in the 1898 photograph (above) as an ideal vantage point from which to view the inaugural trip of the electric railway. The second trough was originally located opposite Adams Store, nestled in the midst of eight elm trees. In 1907, the railroad's at-grade crossing was eliminated and the stone underpass constructed, prompting the current layout of Leonard Street and Concord Avenue. The watering trough was appropriately placed on the new delta. Today, it serves as a reminder of Belmont's horse-and-buggy days.

Sergi Farm is the last working farm in town. Its presence recalls the many market gardens that once thrived here and from which wagonloads of fine produce were carried in to Boston. The farm operates on about six acres of land that are part of the Hill-Richardson land grant. King Charles I of England granted to Abraham Hill *c.* 1633 a sizeable property running along Alewife Brook and the Mystic River all the way to the harbor in Charlestown. Fresh-picked corn, vegetables, and flowers are available right in town at Sergi Farm during the summer and early fall. With the advice and counsel of the Belmont Land Trust in 2003, the property, still family-owned, is now protected from development under conservation and agricultural restrictions.

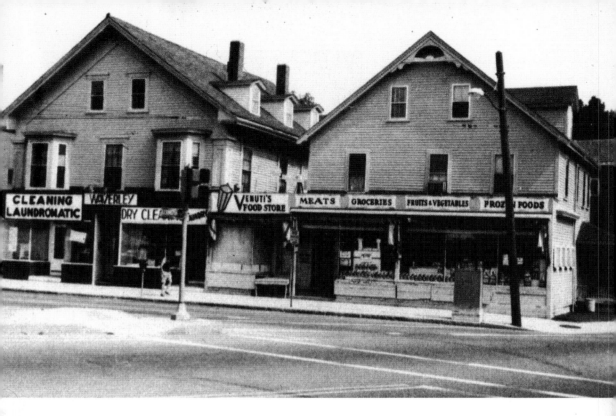

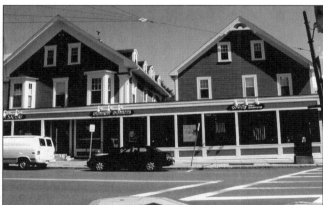

Waverley Hall was located on the railroad station side of Church Street and then was moved permanently across the street to 44–48 Church. A general store was on the ground floor of Waverley Hall, with a meeting hall and areas for the social life of the community above. The post office was an 8- by10-foot space in the store. Early meetings of the Waverley Congregational Church were held in Waverley Hall. In 1932, the Waverley Laundromat and Bing's Laundry occupied the first floor, and two families lived in the upper-floor apartments. Best Cleaners is housed on the street floor of the building today. The structure is one of the few unaltered 19th-century commercial buildings in town. The recent refurbishment has greatly improved the appearance of the building without appreciable change.

This historic boundary stone still marks the common spot between the three towns from which Belmont took its lands. The granite stone was most likely set in 1738, when a precinct of Watertown was incorporated as Waltham, to mark the junction point of the old and new towns at the Cambridge line. Triangular in shape, it is etched with the letters "W," representing 2.26 square miles of Waltham, "C," representing 2.82 square miles of Cambridge, and "W," representing .67 square miles of Watertown. Standing off Center Avenue as a reminder of the early history of the region, the landmark in 1959 attracts the attention of local women Mrs. Baldwin, Mrs. Claflin, and Miss Luard

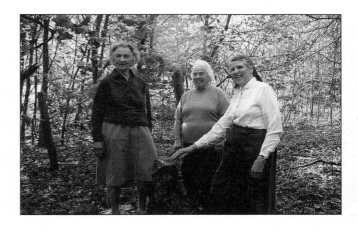

(below). The marker is revisited in 2004 by descendants of the Hill-Richardson, Atkins-Claflin, and Underwood–Wellington families (above).

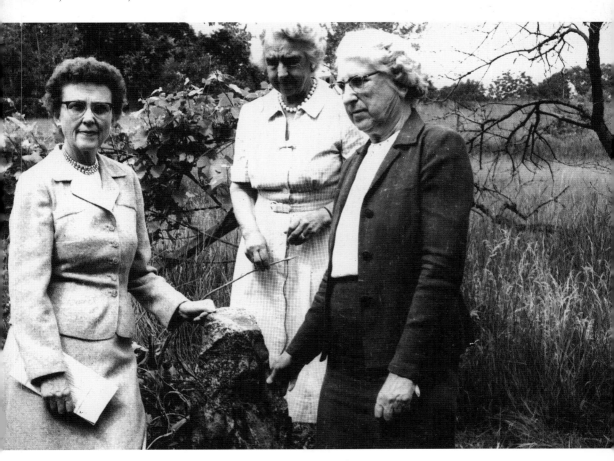

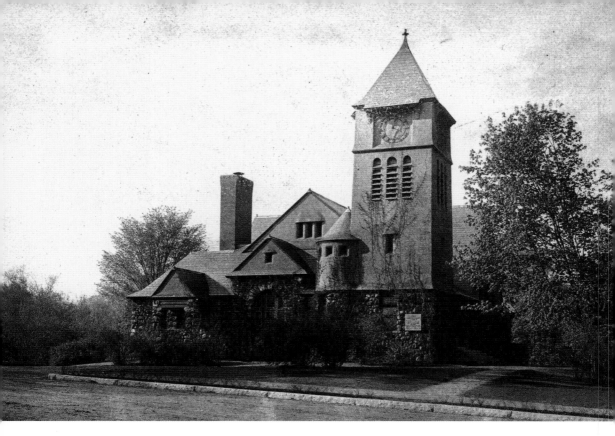

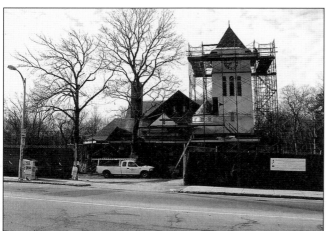

The clock in the tower of the First Church of Belmont, Unitarian, belongs to the people of Belmont rather than to the church. It was installed by the E. Howard Watch and Clock Company at a cost of $500. The original clock had two sets of weights—one for the striking mechanism, another for the timepiece. Until 1971, these weights were hand cranked. Now, only the time mechanism is still hand wound. The striking mechanism is electrically assisted. Since its installation, the town has paid for the clock winding. The price was $36 a year when J. W. Dean started the job in 1890. Today, the cost has risen to $150. Listen carefully on Halloween night. Did the clock strike 13?

In 1925, P. R. Winters opened Winters (Plumbing and Heating) Hardware on the street level of the Winters Block in Cushing Square. It was flanked by the Yaeger and Weeks Company, a Hudson and Essex car dealer, and F. W. MacFarland Real Estate and Insurance. A beauty shop was on the second floor. A pair of two-family houses were moved back from Trapelo Road in 1929 to make room for a five-store addition to the block. The design provided a large second-floor social hall, an important neighborhood gathering spot. Apartments now occupy the space formerly known as Payson Hall, where many young people donned white gloves for ballroom dancing classes. Winters's store changed hands in 1996 but looks very much the same, both inside and out. (Below, courtesy of Paul Winters.)

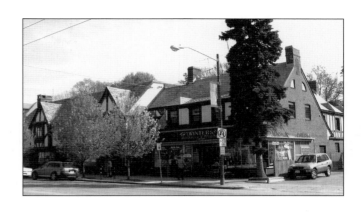

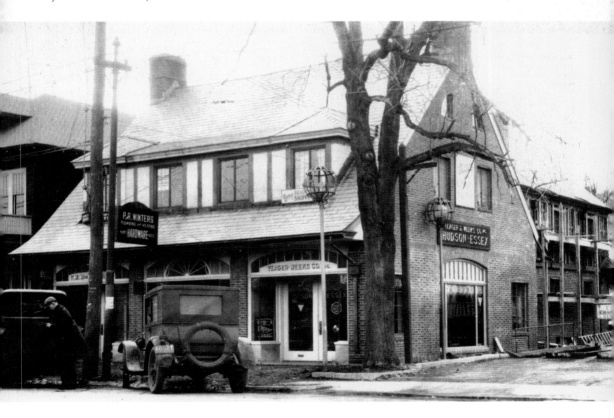

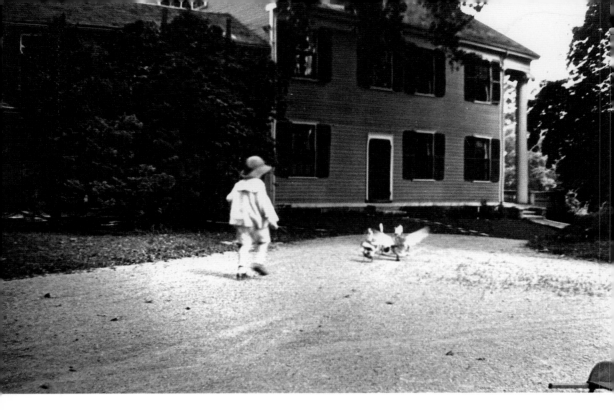

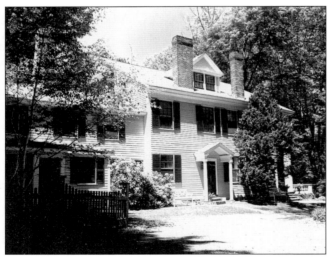

This house was the second of two homes built by Samuel Orlando Mead and his wife, Maria. The first was originally constructed across the street from Maria's father, Jeduthan Wellington, who sold the couple the property of a former fruit orchard. The federal house built on that property was eventually sold to brother-in-law William Flagg Homer, who moved it to its current location, at 504 Concord Avenue, to allow for his larger summer house. Next, in 1836, the Meads built this Greek Revival house, which has been owned by descendants of the family ever since. In 1918, Margaret Underwood Wellington enjoys chasing ducks along the driveway. Today, this historic home offers hospitality to travelers from near and far as Belmont's first licensed bed-and-breakfast.